Southbourne Library
Seabourne Road
BH5 2HY

KT-513-170

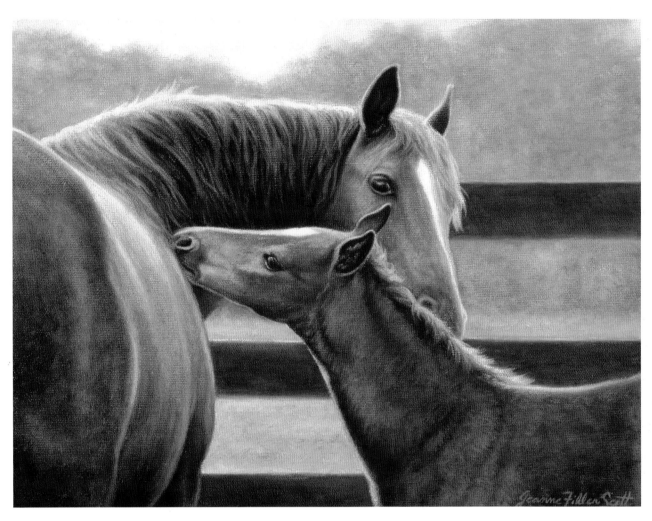

Draw and Paint Realistic Horses

BOURNEMOUTH

410042654

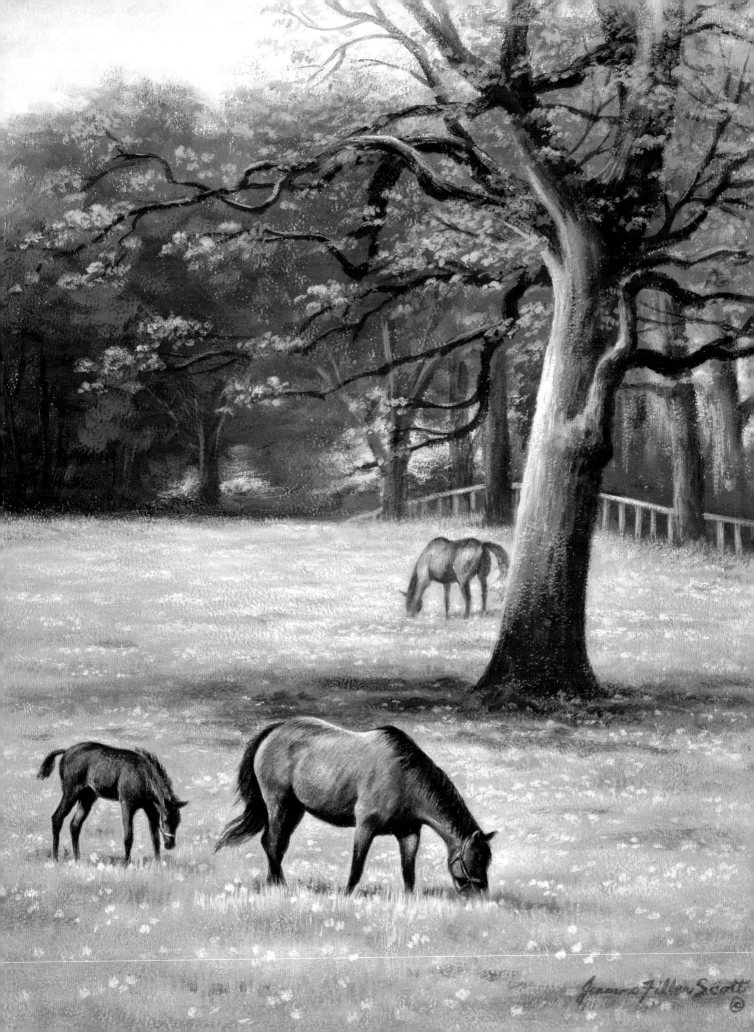

DRAW AND PAINT
Realistic Horses

Jeanne Filler Scott

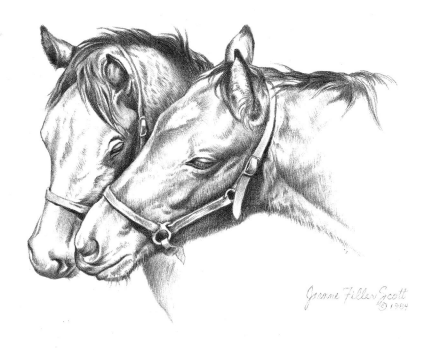

NORTH LIGHT BOOKS
CINCINNATI, OHIO
www.artistsnetwork.com

Dedication

I would like to dedicate this book to our current horse friends Starlight, Squire Horse, Nelly, Epona, Poey, Win Ticket, Chance and Brenna, as well as to our equine friends who have passed on: Smoky, Moonlight and Shammar. They have taught me a great deal about horses, and I have enjoyed their company, getting to know them as individual personalities.

Draw and Paint Realistic Horses: 12 Projects in Pencil, Acrylics and Oils. Copyright © 2010 by Jeanne Filler Scott. Manufactured in China. All rights reserved. The patterns and drawings in this book are for the personal use of the reader. By permission of the author and publisher, they may be either hand-traced or photocopied to make single copies, but under no circumstances may they be resold or republished. It is permissible for the purchaser to paint the designs contained herein and sell them at fairs, bazaars and craft shows. No other part of this book may be reproduced in any form or by any electronic or mechanical means including information storage and retrieval systems without permission in writing from the publisher, except by a reviewer who may quote brief passages in a review. Published by North Light Books, an imprint of F+W Media, Inc., 4700 East Galbraith Road, Cincinnati, Ohio, 45236. (800) 289-0963. First Edition.

Other fine North Light Books are available from your local bookstore, art supply store or online supplier. Also visit our website at www.fwmedia.com.

14 13 12 11 10 5 4 3 2 1

DISTRIBUTED IN CANADA BY FRASER DIRECT
100 Armstrong Avenue
Georgetown, ON, Canada L7G 5S4
Tel: (905) 877-4411

DISTRIBUTED IN THE U.K. AND EUROPE BY F+W MEDIA INTERNATIONAL
Brunel House, Newton Abbot, Devon, TQ12 4PU, England
Tel: (+44) 1626 323200, Fax: (+44) 1626 323319
Email: postmaster@davidandcharles.co.uk

DISTRIBUTED IN AUSTRALIA BY CAPRICORN LINK
P.O. Box 704, S. Windsor NSW, 2756 Australia
Tel: (02) 4577-3555

Library of Congress Cataloging-in-Publication Data
Scott, Jeanne Filler
 Draw and paint realistic horses : 12 projects in pencil, acrylics and oils / Jeanne Filler Scott.
 p. cm.
 Includes index.
 ISBN-13: 978-1-60061-996-0 (paperback : alk. paper)
 ISBN-10: 1-60061-996-7 (paperback : alk. paper)
 1. Horses in art. 2. Drawing--Technique. 3. Painting--Technique. I. Title.
 NC783.8.H65S39 2010
 743.6'96655--dc22 2010025964

Edited by Mary Burzlaff Bostic
Designed by Guy Kelly
Production coordinated by Mark Griffin

Acknowledgments

I'd like to thank all of the horses who are the subjects of the artwork in this book. I would also like to thank the owners and caretakers of these horses, including Bedford Farm, Jane Brooks, Penny Tweedy Chenery, the Dunham family, Nancy Eaton, Elmhurst Farm, Glen Ridge Farm, Pat Goodmann, Hamburg Place, Indian Valley Farm, the Kentucky Equine Humane Center, the Kentucky Horse Park, the Louisville Zoo, Millford Farm, Mrs. Doug Scheumann, Anita Spreitzer, Summerhill Farm, Karen and Mickey Taylor, Three Chimneys Farm, Winifred Madden Morriss, Waterford Farm, Windmill Farm, the World Famous Lipizzaner Stallions, and all the other owners and farms whose names I don't know, but whose equines I saw during my travels and captured as references for drawings and paintings.

QUIET NUZZLE (PAGE 1)
oil on canvas
11" × 14" (28cm × 36cm)
private collection

THE DANDELION FIELD (PAGE 2)
acrylic on panel
16" × 12" (41cm × 30cm)

FRIENDLY FOALS (PAGE 3)
pencil on bristol paper
6" × 7" (15cm × 18cm)

Metric Conversion Chart

To convert	to	multiply by
Inches	Centimeters	2.54
Centimeters	Inches	0.4
Feet	Centimeters	30.5
Centimeters	Feet	0.03
Yards	Meters	0.9
Meters	Yards	1.1

About the Author

Jeanne's work has appeared in many exhibitions, including the Society of Animal Artists, Southeastern Wildlife Exposition, National Wildlife Art Show, Masterworks in Miniature, NatureWorks, Nature Interpreted (Cincinnati Zoo), American Academy of Equine Art, the Kentucky Horse Park and the Brookfield Zoo. Several of her paintings are published as limited edition prints, a number of which are sold out.

Jeanne's paintings are published on greeting cards by Leanin' Tree, and she has been featured on the covers and in articles of magazines such as *Equine Images*, *Wildlife Art*, *InformArt*, *Chronicle of the Horse* and *Hastfocus*, a Swedish horse magazine. She is the author of the books *Painting Animal Friends*, *Painting More Animal Friends* and *Wildlife Painting Basics: Small Animals*. In addition, her work has been included in the books *The Best of Wildlife Art*, *Keys to Painting: Fur & Feathers*, *Painter's Quick Reference: Cats & Dogs*, *Discovering Drawing* and *The Day of the Dinosaur*, which was later re-released as *The Natural History of the Dinosaur*.

She is a member of the Society of Animal Artists and Artists for Conservation (formerly known as the Worldwide Nature Artists Group).

Jeanne and her family live on a farm in Washington County, Kentucky, surrounded by woods, fields and the Beech Fork River. They have eight horses, including Squire Horse and Nelly (Belgian draft horses), Starlight (paint), Epona (pony), Poey (Arabian), Win Ticket (Thoroughbred), Chance (grade) and Brenna (Icelandic pony). She adopted the latter three from the Kentucky Equine Humane Center.

Jeanne, her husband Tim and son Nathaniel often help animals in need, and almost all of their animals were rescued. Their animal family also includes ten dogs, twelve cats, a turtle, two rats, several cows and a mouse. In addition, many wild creatures enjoy the sanctuary of the farm, including opossums, deer, wild turkeys, raccoons, foxes, coyotes, box turtles, squirrels, woodchucks, rabbits, snakes, skinks, crows, owls, hawks, songbirds and buzzards.

See more of Jeanne's work on her website at www.jfsstudio.com and at www.natureartists.com.

Photo by Tim L. Scott

JEANNE AND BRENNA, ICELANDIC PONY
Jeanne and her family adopted Brenna from the Kentucky Equine Humane Center.

Artist's Statement

I have always used art to understand and appreciate the natural world and to bring myself closer to my subjects, primarily animals and their surroundings. Animals are not simply generic classes of creatures. Each is an individual, with distinct characteristics unique to that single animal.

My style of drawing and painting allows me to see and understand the individuality that separates one animal from another. I attempt to impart the spark of life into each painting. When I accomplish that, I am satisfied that my painting has captured a facet of the animal's character, and, in some sense, I have done justice to my subject.

This book is about drawing and painting horses, one of my favorite animals. They have been partners to humanity for so many thousands of years that, as with dogs, we share a unique bond. My equine art celebrates our alliance and, I hope, conveys our joy of kinship.

Contents

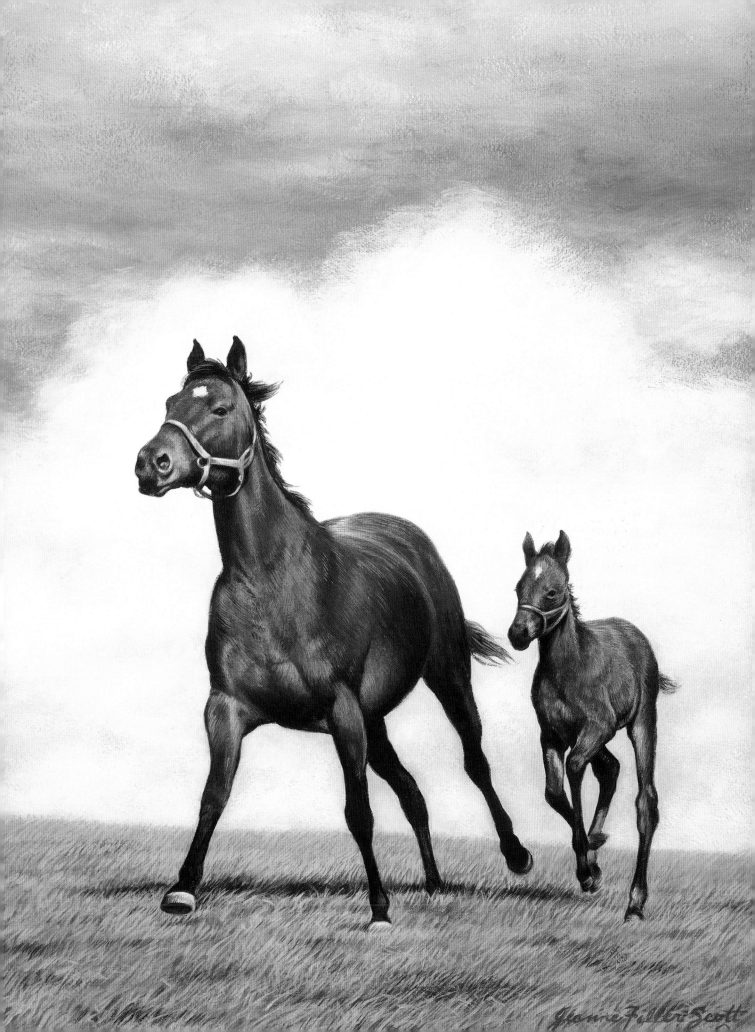

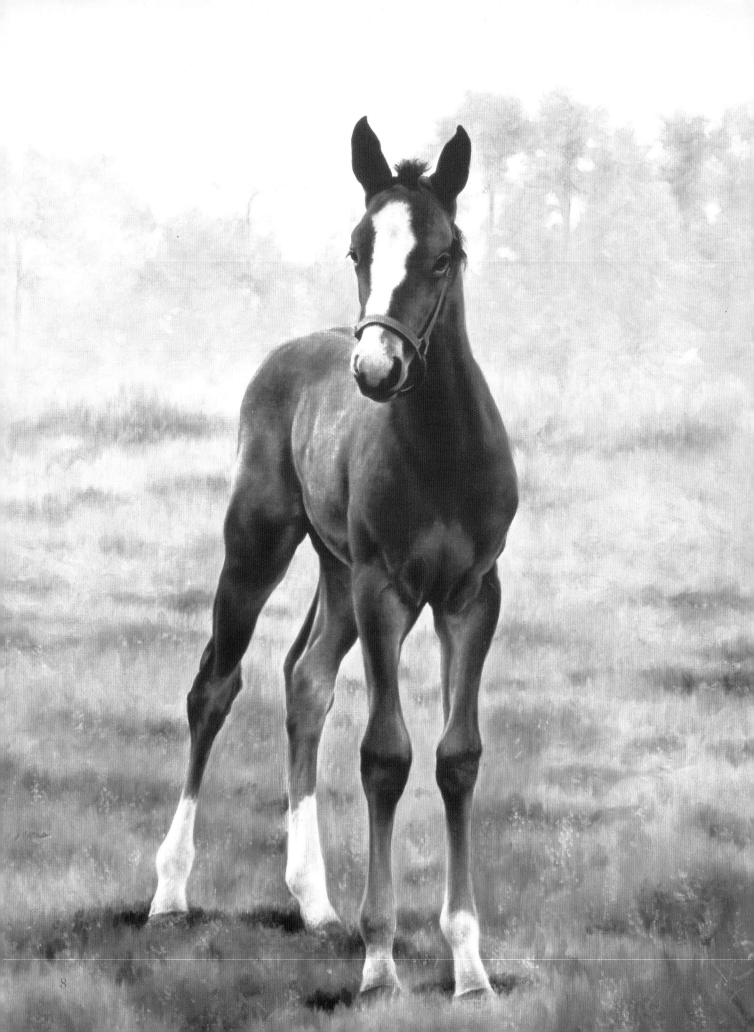

Introduction

Horses are some of the most beautiful animals on earth. Their combination of strength and elegance, as well as the role that horses have played in human history, have made them a favorite subject of artists. Even those who have never had the opportunity to own or to get to know a horse personally admire and feel a closeness with horses.

Whether or not you have horses, you can become a great equine artist. From the age of five, I have drawn horses, even though I grew up in a place where there was no place to keep one. I began drawing horses after I was taken to Almahurst Farm in Kentucky. I still rememb-er how awed I felt at seeing the horses in the barn, their heads looking out at me from their stalls. From then on, I began to draw lots of horses.

When I was a teenager, I was surprised to learn from my father that his father, Gustav Filler, who had died before I was born, was a talented artist who had always liked to draw horses. Although he never owned a horse, he lived when horses and wagons were commonplace, and he would have seen horses every day. My maternal grandfather, Aubrey Brooks, used to drive a horse and buggy and worked at horse farms when he was older. I have both grandfathers to thank for my interest in horses as well as my talent for art.

I did not have my own horse until I was in my late thirties, and I now feel privileged to have eight of these wonderful animals under my protection and care. It's never been something I take for granted. Read books about horses, study artwork by artists whose work you admire, and seek out any opportuni-ties to observe horses. Even in cities, there are mounted police officers and horse and carriage rides. Other places to look for horses include race tracks, parades and horse shows. The more you see horses up close, the more you will learn.

This book will give you step-by-step instructions for drawing and painting many different kinds of horses in different poses and settings. I have also included drawings to give you more insight into horse anatomy as well as the differences between breeds. I hope you learn a lot and have fun!

DRAWING OF A LEAPING HORSE
by Gustav Charles Filler (1872–1947)
pencil on paper • 8″ × 10½″ (20cm × 27cm) • private collection

THE YOUNG ARISTOCRAT
oil on canvas • 27″ × 40″ (69cm × 102cm) • private collection

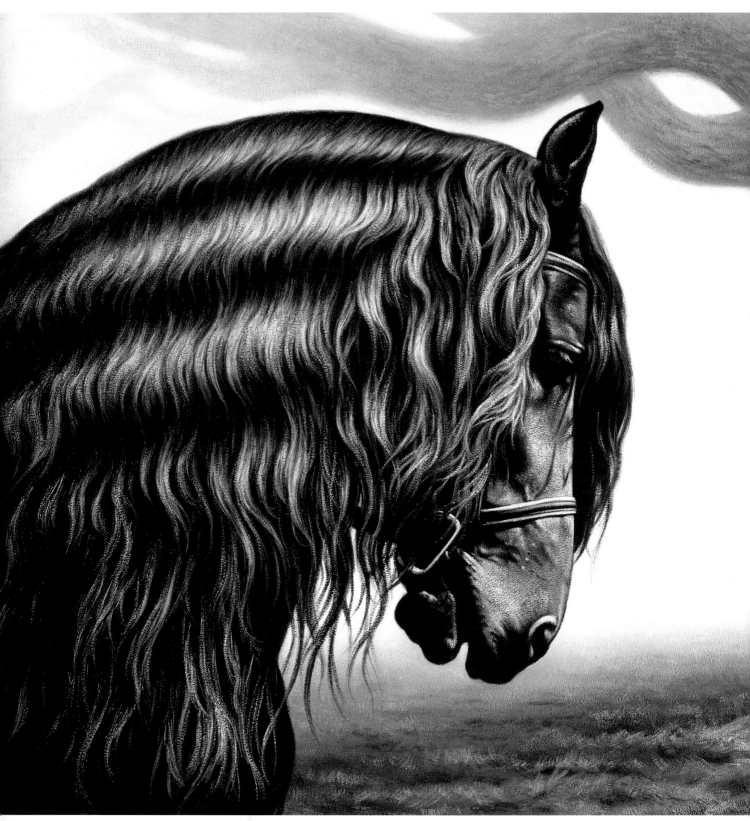

FRIESIAN STALLION
oil on panel • 18" × 24" (46cm × 61cm) • artist's collection

Getting Started

To get started drawing and painting, you will need the right supplies. You don't have to buy the most expensive art supplies but you should get the best available to you. Remember, the most expensive brushes aren't the key to becoming a master, and a good artist can use moderately priced brushes to produce a masterpiece!

Three mediums are used in this book: acrylics, oils and pencil. In this section, I'll provide you with a list and description of everything you'll need for each medium. I'll also cover some basic techniques to get you started drawing and painting as well as finding references.

Drawing Materials

We'll start with pencil drawings, which require just a few simple materials:

Surface

Bristol paper with a smooth finish makes an excellent surface for fine pencil work and withstands some erasure without roughening the paper surface. You can also use hot-pressed illustration board, which has slightly more texture than the Bristol paper and can also withstand erasures.

Pencils

Use a no. 2 pencil for your preliminary underlying sketch, whether you're sketching directly on the bristol paper or transferring your sketch with tracing paper.

For the final drawing, use ebony pencils. They are jet black and smooth to work with because they are softer and denser than ordinary pencils. This also makes them easier to blend with a stump. I use Sanford Design pencils, but other companies also produce similar products.

Kneaded Eraser

The kneaded eraser is best for pencil work as it erases cleanly and can be formed into any shape for detailed erasures. Also, you can easily clean the eraser by kneading and working it around. You can use a kneaded eraser to lighten areas that have gotten too dark by repeatedly pressing the eraser lightly onto the area until it is the right tone.

Blending Stump

Similar to tortillions, stumps are made of soft, tightly spiral-wound paper. They are a good tool for smoothing and blending and give a softer look to some areas of your drawing than can be achieved by the pencil alone.

Pencil Sharpener

It's important to have a good pencil sharpener, preferably electric, so you can quickly sharpen your pencils to a fine point. It's a good idea to sharpen several pencils at once so when one gets dull, you don't have to stop to sharpen it.

Spray Fixative

Spray fixative stabilizes drawings so that the penciling won't smudge or smear if it is accidentally touched or rubbed. Workable fixative is best since it provides lasting protection, yet you can still rework the drawing if you decide to make changes. Apply it in a place with plenty of ventilation, placing the drawing on a larger piece of scrap paper or cardboard so you don't get the spray onto anything else. Cover the surface uniformly but without drips.

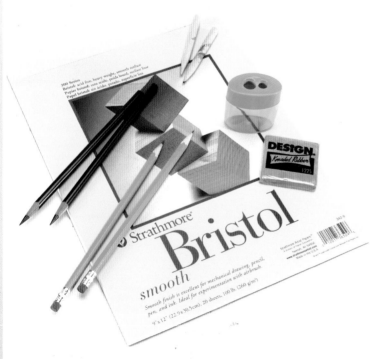

Gather Your Supplies

Here is what you'll need for your pencil drawings: a surface (Bristol paper or illustration board), a no. 2 pencil, ebony pencils, kneaded eraser, blending stumps and spray fixative. It's also useful to have a good pencil sharpener and tracing paper for transferring your sketch to the surface. Drawing supplies are relatively inexpensive and easy to order over the Internet.

Painting Materials

As you'll see, the list of materials you'll need for painting is more extensive than for drawing. However, once you've purchased basic painting supplies, they are well worth the expenditure since they'll provide you hours of satisfaction and enjoyment as you create your own paintings.

Surface

The surface for most of the oil and acrylic painting demonstrations in this book is Gessobord, a preprimed Masonite panel with a nice texture for realistic painting. It comes in a variety of sizes. I completed most of the demonstrations in this book on 8" × 10" (20cm × 25cm) panels. I used hot-pressed illustration board for the horse eye and mane demonstrations. Illustration board is fine for acrylic paintings, but since it is paper based, it is not suitable for oils. Although I prefer Gessobord for finished oil and acrylic paintings because of its permanence and smoother surface, illustration board has the advantage of being less expensive to buy and it can be easily cut to any size you desire.

Paper Towels

Paper towels are useful for blotting excess paint, water, turpentine or medium from your brush. Keep a folded paper towel by your palette and a crumpled one in your hand or on the table.

Versatile Materials
Many of the same materials used for oil painting can also be used for acrylics—brushes, surface (Gessobord), palette knife, paper towels, no. 2 pencils and tracing paper. The difference is in the paints (oil or acrylic), medium (Liquin or water) and type of palette (disposable wax paper or Masterson Sta-Wet Palette).

Medium

Medium improves the flow of the paint so it is easier to spread and blend, and it can also be used for glazing. For acrylics, I use plain water instead of a manufactured medium. For oil painting, I use Winsor & Newton Liquin. It improves the flow of paint, makes the paint dry faster and is good for blending and glazing. I use turpentine or a turpentine substitute to thin a neutral color for blocking in the form in the first step of the painting, and for cleaning brushes.

When painting with acrylics, it's important to change the water fairly frequently so it doesn't get too murky with paint. For oils, you may have to change your turpentine occasionally if it gets too saturated with paint. Always wipe as much paint from your brushes as possible with a paper towel before cleaning them.

No. 2 Pencil and Kneaded Eraser

You'll need a pencil and an eraser for drawing or tracing the image onto your panel. The kneaded eraser is good for making corrections and for lightening pencil lines so that they won't show through the paint.

Tracing Paper

You'll need tracing paper if you want to trace your sketch or the template drawing provided with each demonstration. After tracing your sketch, you can transfer it to the Gessobord using homemade carbon paper (see page 18). The advantage of doing the sketch on a separate piece of paper, and not directly onto the panel, is that you have much more control over the size and placement of the subject, often resulting in a better painting.

Varnish

When an oil painting is completely dry (which can take six months to a year, depending on how thick the paint is), it should be varnished with a final picture varnish for total surface protection and to restore colors. You should keep a schedule and inform people who receive your art that they or someone else must apply the varnish to preserve the value of their acquisition. Although it isn't necessary, some artists also choose to varnish acrylic paintings because they want the painting to appear glossier or to add a protective layer.

Palette

The Masterson Sta-Wet Palette works well for acrylics because it keeps your paints from drying out for days or even weeks. The 12" × 16" (30cm × 41cm) size is best as it gives you plenty of room to mix colors. The palette consists of a 1¾" (4cm) deep plastic box with a sponge insert that fills the bottom of the box when wet. A special disposable paper, called acrylic film, sits on top of the sponge insert. The box has an airtight lid.

For oil painting, I use a 12" × 16" (30cm × 41cm) disposable wax paper palette. When you are finished with a sheet, you just tear it off and discard and use the new sheet underneath. A plastic box with a lid (similar to the one for the Masterson Sta-Wet Palette) will help keep your paints from drying out.

Palette Knife

You'll need a palette knife for mixing both oil and acrylic colors. A tapered steel knife works best, and the trowel type with a handle lifted above the blade is the easiest to use. Be sure to clean your palette knife between colors. Wiping it on a paper towel is usually sufficient, but occasionally you'll have to rinse it in water or turpentine.

Wax Paper

It's useful to keep wax paper on hand for times when you want to paint a thicker acrylic layer (the Sta-Wet Palette always adds some water to the paint). Simply transfer some color from your palette to the wax paper. The wax paper will prevent the paint from becoming diluted, and the paint will immediately begin to dry out and thicken. Lightly spray the paint with water to keep it from drying up completely.

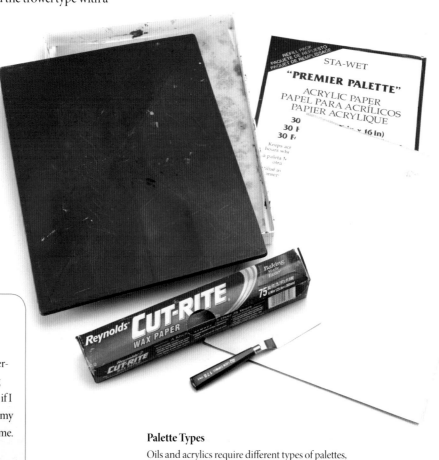

Acrylic Palette Tip

The directions that come with the Masterson Sta-Wet Palette tell you not to wring out the wet sponge. However, I find that if I don't gently press out some of the water, my paints become too runny after a short time. If the paints start to dry out, spray them lightly with water from a spray bottle.

Palette Types
Oils and acrylics require different types of palettes, but you can use the same palette knife for both mediums.

Brushes

I keep on hand dozens of brushes in all different brands, types and sizes. The numbers used to designate the sizes of brushes vary widely from one manufacturer to another. For example, a no. 1 round of one brand could be a very small brush used for detail, while a no. 1 round of a different brand could be much larger and not at all suitable for small detail. I've found that even within one brand, the length of the handle (long or short) can make a big difference in the size number. When I paint, I tend to pick up any brand of brush in a size and type that looks right for what I am doing. This method seems the most practical.

However, to make it easier for you, I've limited the brushes in this book to one brand: American Painter made by Loew Cornell. They are made of a synthetic sable called golden Taklon and have firmness as well as flexibility. In order to have the right mix of types and sizes, I have used both long- (Series 4250KF) and short-handled (Series 4000) brushes. Because sizing is quite different from the long to the short handled brush, I will designate which series each brush is from to avoid confusion.

There are seven brush sizes used for the demonstrations in this book, including:

Rounds: no. 1, no. 4 and no. 6, all American Painter (Series 4000) with short handles.

Filberts: no. 6 and no. 10 (Series 4500) with short handles and no. 2 and no. 4 (Series 4250KF) with long handles. Be aware that the long-handled no. 4 filbert is a larger brush than the short-handled no. 10 filbert!

Rounds come to a fine point and are best for detail, such as a horse's eye or blades of grass. Filberts are good for broader areas such as a horse's body or large areas of grass or sky. They hold a lot of paint and are tapered so that it's easier to paint around objects.

It's best to have two or three of the more frequently used brushes, such as nos. 1 and 4 rounds and nos. 2 and 6 filberts. As you'll see in the demonstrations, you will often need two or three of the same size brush, each with a different color, so you can use them alternately while blending.

You can use the same brushes for the oil and acrylic demonstrations in this book. Just be sure to wash the brushes well at the end of your painting sessions. For acrylics, you need only to rinse the brushes well in water. For oils, you must rinse the brushes out well in turpentine or turpentine substitute, blot on a paper towel, then use water and a brush cleaner such as The Masters Brush Cleaner and Preserver to complete the cleaning. You can also use dish soap for this purpose.

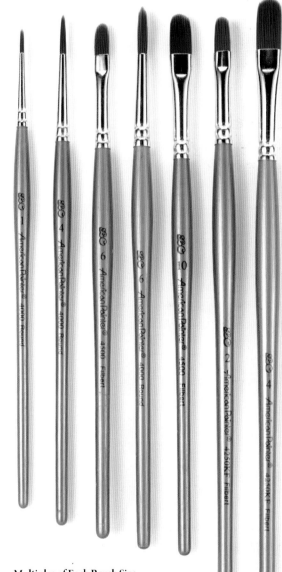

no. 1 round (short handled) | no. 4 round (short handled) | no. 6 filbert (short handled) | no. 6 round (short handled) | no. 10 filbert (short handled) | no. 2 filbert (long handled) | no. 4 filbert (long handled)

Keep Multiples of Each Brush Size

With this set of brushes, you can do any painting in this book. It's a good idea to have two or three copies of each of the round sizes and at least two of each of the Filberts. That way, you can use two or three brushes alternately with different colors to blend without having to stop and clean your brush each time.

Acrylics

I painted the demonstrations in this book with Liquitex Heavy Body Professional Artist Acrylic Colors that come in tubes. I like these paints because they have a good consistency—smooth but not runny—and can either be thinned to a watercolor type glaze or applied in a thicker, more opaque layer with lots of possibilities in between. They are also permanent, richly colored, and will not crack or yellow when dry. However, there are many brands of acrylic paint available, so experiment and find out what works best for you. The colors I used in this book include: Burnt Sienna, Burnt Umber, Cadmium Orange, Cerulean Blue, Hansa Yellow Light, Hooker's Green, Naples Yellow, Neutral Gray (value 7.0), Raw Sienna, Red Oxide, Scarlet Red, Titanium White, Ultramarine Blue and Yellow Oxide.

Mixing Acrylic Colors

Painting with pigments straight from the tube results in garish, unrealistic colors. Most of the colors you use will be a mixture of two or more pigments.

Be sure to mix a large enough quantity of each color so that you have enough to finish the painting. This is easier than trying to mix the same color a second time. Save all of your color mixtures until you have completed the painting. You never know when you may need a color again to reestablish a detail, for example. You can also use a previously mixed color as the basis for a new color by simply adding another color or two to a portion of a mixture you've already created.

Acrylic Color Requirements

Here are a few of the acrylic paints I use in this book. The colors required in the demonstrations vary with the subject, some requiring more or different colors than others.

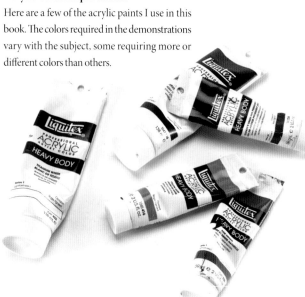

Useful Acrylic Mixtures

Here are some useful color mixtures:

Warm black: Mix Burnt Umber and Ultramarine Blue for some horse's coats, manes or tails. This black looks more natural than black from a tube.

Warm white: For painting highlights on a horse's coat, clouds or wildflowers, mix Titanium White and a touch of Hansa Yellow Light or Yellow Oxide.

Basic green: Mix a basic green for grass and trees with Hooker's Green, adding a little Cadmium Orange and Burnt Umber to tone down the green. For darker shadows, mix in some Ultramarine Blue and more Burnt Umber. For highlight colors, add some Titanium White and Naples Yellow or Hansa Yellow Light.

Basic grass: Mix a basic grass color with Hooker's Green, Titanium White, Naples Yellow and a little Cadmium Orange.

Bluish green: For distant trees, mix Titanium White, Hooker's Green, Ultramarine Blue and a bit of both Cadmium Orange and Raw Sienna.

Natural pink: For the muzzle and corner of the eye of some horses, mix Titanium White, Scarlet Red and Burnt Umber or Burnt Sienna.

Bluish shadow color: For shadowed areas in light or white parts of a horse's coat, mix Titanium White, Ultramarine Blue and a little Burnt Umber or Burnt Sienna.

Blue sky: Mix this color with Titanium White, Ultramarine Blue and a touch of Naples Yellow. For a brighter blue, use Cerulean Blue instead of Ultramarine Blue.

Oils

I completed the oil demonstrations in this book with Grumbacher Pre-tested Oil colors, with the addition of Permalba White, a product of the Martin/F. Weber Co. Permalba White, a mixture of Titanium White and Zinc White, has a creamy, spreadable texture that makes it easy to paint with and to mix with other colors. The oil colors I used in this book include: Burnt Sienna, Burnt Umber, Cadmium Orange, Cadmium Red Light, Cadmium Yellow Light, Cerulean Blue, Indian Red, Naples Yellow, Permalba White, Raw Sienna, Ultramarine Blue Deep, Viridian and Yellow Ochre.

Oil Color Mixtures

Oil color mixtures are basically the same as the acrylic mixtures, except some of the colors are a little different and have different names (never mix oil and acrylic paints). Substitutions for acrylic to oil are as follows:

- For Ultramarine Blue, use Ultramarine Blue Deep. (Ultramarine Blue is available in some oil brands, but Grumbacher makes Ultramarine Blue Deep.)
- For Scarlet Red, use Cadmium Red Light.

- For Titanium White, use Permalba White. (Titanium White is also an oil color, but I prefer Permalba White.)
- For Hooker's Green, use Viridian.
- For Yellow Oxide, use Yellow Ochre.
- For Hansa Yellow Light, use Cadmium Yellow Light.
- For Red Oxide, use Indian Red.

Retouch Varnish

Oil paints tend to dry to a duller finish than when wet, which can make matching color mixtures difficult in subsequent painting sessions. Try applying damar retouch varnish once the painting is dry to the touch. Be sure to use with plenty of ventilation. The varnish takes only a few minutes to dry. Retouch varnish temporarily restores the luster and color to a painting so that it looks the same as when you first applied the wet paint. Since it is thin, retouch varnish allows the paint to keep drying underneath, which will prevent it from cracking later. When the painting is finished and fully dry, apply the final picture varnish. The colors will be restored and will all match because you used retouch varnish when starting each new painting session.

Oil Paint Brand Choices
I like Grumbacher oil colors because they are archival and permanent with rich color and a smooth consistency. There are many brands of oil paints available, so experiment and find out what works best for you.

Test Your Mixtures

When mixing a color on your palette, you can't be certain how it will look in the painting until you see it next to the other colors. Test the mixture by placing a small dab on the area to be painted. You can then modify the color so it will be the best for your painting.

Beginning a Drawing or Painting

I always begin my drawing or painting with a good sketch on a separate piece of paper using a no. 2 pencil. Once I have perfected the sketch, I transfer it to the drawing or painting surface with tracing paper and homemade carbon paper. If I'm doing a drawing, I'm ready to use my ebony pencils to start shading. If I'm doing a painting, I first do an underpainting to establish the basic forms. In both drawing and painting, it is a process of building, adding and refining with each step until I am finished.

Transferring Drawings

I've provided a template drawing of the subject with each demonstration in this book. You can use these templates or create your own sketches. Either way, you'll need to use a piece of tracing paper and a sharp no. 2 pencil to transfer the image onto the surface.

You can enlarge or reduce the size of the image to fit your panel using a copy machine or an opaque projector. If you use an opaque projector, you can trace the image directly onto the panel from the projected image. This is a little challenging, since you have to stand to one side so your shadow doesn't block the light. The advantage to doing your sketch on a separate piece of paper and then tracing it onto the bristol paper is that you make most of your trial variations and determine the size and composition of your drawing before committing the image to the final surface.

Underpainting or Preliminary Sketch

Once you have a pencil sketch on your panel or paper, you are ready to start drawing or painting. For a drawing, lightly reinforce the lines of the sketch with a well-sharpened ebony pencil. Indicate where the areas of major shading will be with light, sketchy lines. For a painting, use a neutral color such as Burnt Umber thinned with water (for acrylics) or turpentine (for oils). Make the paint thin but not too runny. Paint lightly, not worrying about detail at this point. Just establish the main lines and the light and dark areas. The purpose of the underpainting is to give you a rough guide to go by when you begin painting in full color.

Completing a Drawing or Painting

Once you have finished the sketch or underpainting, it's time to apply the darkest values. Follow with the middle values and then the lightest values. Start with little detail, then build upon it, adding more detail with each step. Doing a realistic drawing or painting is basically a process of refining as you go along, building upon what you've already done. In the final step, you will add the finishing details.

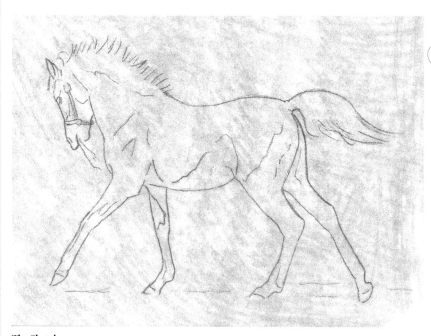

The Sketch
With homemade carbon paper positioned underneath, the sketch is easily traced onto the panel.

DIY Carbon Paper

Most carbon paper available for sale is waxy and can interfere with paint adherence. Also, commercial carbon paper usually only comes in small sheets. Make your own carbon paper by blackening the back of a blank piece of tracing paper with a no. 2 pencil. You can use this homemade carbon paper over and over.

Pencil Strokes and Brushstrokes

Here are some useful brush and pencil strokes to make your drawing or painting more realistic.

Types of Brushstrokes

Dabbing Vertical Strokes: Make these quick strokes with a vertical motion, using either a round or a filbert brush. Vertical strokes are good for painting the texture of grass in a field.

Smooth Flowing Strokes: These strokes are good for long hair, such as a horse's mane or tail. Use a round brush with enough medium so the paint flows. Make flowing and slightly wavy strokes.

Dabbing Semicircular Strokes: Make these strokes fairly quickly, in a semicircular motion, with a filbert. These strokes are good for skies, portrait backgrounds or other large smooth areas.

Small Parallel Strokes: Use these strokes to paint detail, such as the short hair of a horse's coat. Using a round brush, paint in the direction of the horse's contours or hair growth pattern.

Glazing: Use a glaze to modify an existing color by painting over it with a different color thinned with medium, allowing the original color to show through. (The original color must be dry before you paint a glaze over it.) This creates a new color that you couldn't have achieved any other way.

Smooth Horizontal or Vertical Strokes: These strokes are good for manufactured objects and water reflections. Using enough medium so the paint flows but is not runny, move a round brush evenly across the surface of the panel.

Drybrush or Scumbling: Use dry-brushing or scumbling to modify an existing color by painting over it with another color in an opaque fashion, using broken strokes so the original color shows through. (The original layer of color must be dry first.) Dip a moist brush into paint, then rub lightly on a paper towel so there is just enough paint to create rough, uneven coverage. Repeat as necessary.

Types of Pencil Strokes

Smooth Parallel Strokes: With constant pressure on the pencil, lightly draw parallel lines of roughly the same length. This is a good basic shading technique.

Crosshatching: Shade with parallel lines, then shade over the first set of lines with strokes that go in a different direction. Crosshatching darkens areas more smoothly than simply shading in one direction.

Blending With a Stump/Tortillion: Rub a stump over pencil shading to soften and blend. Create different effects by varying the direction and pressure on the stump.

Layering Lines and Blending: Adding more pencil shading over a blended area can yield nice effects. Use the stump again, alternating between pencil and stump to achieve the desired texture.

Long, Curving Strokes: Use these strokes for tall grass, weeds and strands of hay or straw.

Flowing Strokes: These pencil strokes are good for flowing manes and tails.

Straight, Slightly Curved Strokes: Use these strokes for the stiff, slightly bending hairs of a donkey or zebra mane. These strokes are also good for depicting mowed grass.

Creating Backgrounds

When painting a horse in a landscape, the background is almost as important as the horse itself. A beautiful painting of a horse will be enhanced by a well-painted landscape but will be downgraded by a rushed, sloppy landscape.

Working on the horse and the background simultaneously will make it much easier to integrate the horse into its surroundings. In a painting where the subject is defined by the background colors, such as a white horse against dark trees, you will need to paint the background earlier in the process.

There are two types of backgrounds used in the demonstrations in this book: portrait backgrounds and landscape backgrounds.

Portrait Backgrounds

A portrait background is a good choice when a detailed background would distract from the subject, such as when painting a head portrait, or when your objective is to focus solely on the horse. This background is composed of a fairly neutral color, often with lighter and darker shades of the color. You can add depth by working in darker tones of the color, usually at the upper and lower parts of the painting. Smoothly blend these darker tones into the main color. Another variation can be achieved by drybrushing another color over the original color. If the entire body of the horse is shown, paint a shadow or a few sprigs of grass around the horse's feet.

Landscape Backgrounds

Landscape backgrounds are more challenging, but they can add a lot to a painting. The landscape doesn't need lots of detail to be effective. In fact, too much detail in the background can distract the viewer from the main subject. Paint just enough detail to make the background look realistic.

Landscape Background Brushstrokes

Painting Trees: Paint trees with a basic green color mixture, using dabbing strokes and a filbert. With a lighter green and a round brush, paint detail to suggest clumps of leaves.

Foreground Grass: Paint foreground grass with a dark green shadow color and a lighter basic grass color. Use round brushes to paint flowing, slightly curving strokes that taper at the ends and go in various directions, the way grass grows. Overlap the greens and add some brown detail to integrate the horse and/or add a natural look. Most grass does not look as perfect as a golf course!

Broad Areas of Grass: Paint broad areas of grass with a combination of vertical and horizontal brushstrokes, with mostly vertical strokes in the foreground. Transition to more horizontal strokes farther back. Make the strokes smaller as they recede into the landscape.

Clouds: Paint clouds in the sky with a warm white mixture. Use a filbert and light, feathery dabbing strokes to paint the clouds right over the blue sky color. Use a separate brush and the blue sky color to blend the undersides of the clouds with the sky. Clouds often subtly reflect the colors of the landscape beneath them, but be careful not to overdo it.

Skies: Paint skies with dabbing, semicircular strokes and a fairly large filbert. Make the sky lighter at the horizon by adding more white to a portion of the basic sky color, blending where the two colors meet.

Finding Horses to Draw and Paint

Here are some places to find horses:

Horse Farms

Most horse farms specialize in one or sometimes two horse breeds. While some farms are open to the public, most are private, and entrance requires the permission of the owner or manager. Write a letter to the appropriate person, enclosing some photos of your paintings, and you may get a good response and an appointment to visit the farm to view and photograph the horses.

Horse Parks

Most horse parks focus on horse shows and events, which provide good reference-gathering opportunities for the equine artist. I am fortunate to live close to the Kentucky Horse Park near Lexington, where they not only sponsor horse shows, but also keep many breeds of horses, have a farrier shop and an equine museum, often with exhibitions of equine art.

Fairs

Fairs are a good place to see horses. They often sponsor horse shows as well as display many kinds of farm animals, including horses, ponies and donkeys.

Race Tracks

At thoroughbred and standardbred race tracks, you can see the horses racing and visit the barns and exercise areas to see behind the scenes.

Driving in the Country

I've captured some of my best reference material while driving the countryside. When I happen upon compelling horses and landscapes, I pull over to take reference photos. Remember, never climb over a fence or go into a field with horses without getting the owner's permission.

In the City

Even if you live in the city, there are opportunities to see horses. Many cities have mounted police, riding stables and horse-drawn carriages. There are also indoor horse shows such as the World Famous Lipizzaner Stallions. Special events frequently include parades that feature horses such as the Budweiser Clydesdales.

Sanctuaries and Rescue Organizations

Many horse sanctuaries and shelters for abused and abandoned horses provide permanent homes, while others look for good homes for the horses. Many will allow visitors either during certain times or by appointment. For a complete listing of horse sanctuaries, go to www.equinerescue.info/links.html.

Renaissance Fairs

Most Renaissance fairs have horses, usually with riders dressed as medieval knights jousting with lances. This can be very colorful and interesting to watch.

Civil War Reenactments

Horses are an integral part of Civil War reenactments, and there are often mules pulling supply wagons as well as an assortment of riding horses for officers and cavalry.

Zoos

If you want to see zebras or other wild relatives of the horse, a zoo is a great place to sketch and take reference photos. Besides zebras, you may be able to see an onager or a Przewalski's horse.

Don't Forget Your Camera!

Pay no heed to those who look down their noses at using photographs as reference. Many famous artists, including Edgar Degas, Thomas Eakins and Frederic Remington, painted horses from photos. To limit yourself by not using them just because they were not available to the Old Masters, would make about as much sense as not taking advantage of modern medicine or not driving a car. A photograph simply renders an object in motion still, similar to a cooperative human subject or a still life.

Gathering References

Always carry your camera and sketchbook so you can take advantage of opportunities—you never know when you'll see a horse or landscape you'd like to photograph or sketch. You'll enjoy looking at your photos and sketchbooks later to see what you have captured and to remember the experience.

Photography

If you are serious about painting horses in a realistic, detailed style, photography is an important tool. Since horses are constantly in motion, even when at rest, getting good photos can be a challenge. Take lots of horse photos for practice. Sketching is also important, but photographs preserve a moment in great detail. This gives you a lot more information to work from and more flexibility as an artist.

Camera Equipment

While I used to take all my reference photos with a 35mm film camera, a few years ago I began using a digital camera. Now I can take hundreds of photos without running out of film. A digital camera is also smaller and more portable than a film camera with multiple lenses. It's best to purchase a digital camera with a zoom lens built in. With good lighting, even a moderately priced digital camera will take good reference photos.

Tips for Photographing Horses

There is more to photographing horses than simply pointing and clicking. Here are some tips:

- For side-view conformation poses, make sure that the horse looks balanced and that all four of the legs are placed so there is a clear silhouette of the legs up to the knees or hock joints. The horse's head should be up with the ears pricked forward.
- For head portraits, the horse should look alert and interested. You have more latitude with informal poses, since there are many appealing poses where the horse may have his ears flopped out.
- Take a lot of photos. This will increase your chances of getting a really good reference.
- Photograph details, such as heads, eyes and hooves. Often, the smaller details don't show up well in photos of the entire horse.

A computer and color printer are helpful for enhancing, cropping, enlarging and printing your photos. If this isn't an option, most copy shops can print your digital photos.

Taking Background Photos

In the excitement of photographing the horse, don't forget to photograph the horse's environment if the location is appropriate. Later on, when you are working in your studio, you'll be glad you stopped to take a few photos of the background.

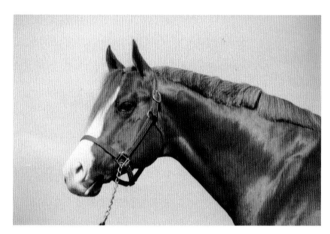

Portrait Shot
This is a good head portrait photo. This is the paint stallion Titan A Rama at Indian Valley Farm in Kentucky.

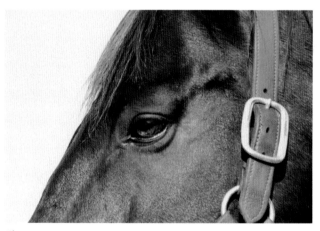

Closeups
Take close-up photos of the horse's details. This is the eye of famous racehorse Seattle Slew.

Combining Photos

You can combine elements from different photos for use in a drawing or painting. When using more than one photograph, be sure to draw or paint the background so all light is coming from the same direction (if there is a strong light source).

Filing Your Photos

File your photos so you can find them when you need them. The more specific you make your files, the more useful they will be. Some of my file folder labels include Foals, Standing; Foals, Heads; Mares and Foals, Paint; and Mares and Foals, Thoroughbreds, Grazing.

Sketching

Sketching is a great way to observe horses and have fun at the same time. While you'll discover that horses seldom hold a pose for more than a few seconds, you'll learn a lot about their anatomy and character.

Books

Well-illustrated books about horses are a good source of information, but don't use an image from a book as your primary reference (this would constitute plagiarism). Look for books on different breeds, horse encyclopedias, horse picture books and books on equine art at used bookstores and library book sales, where you can buy books for a fraction of what they cost new.

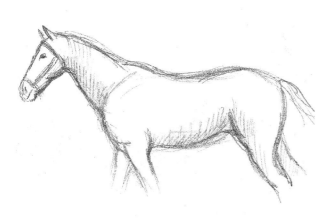

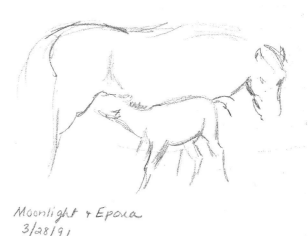

Sketch of a Thoroughbred

I sketched this Thoroughbred at a horse sale. I enjoyed the challenge of quickly capturing the essential lines of the horse. Although there is not enough information in a sketch to use as a reference for a finished drawing or painting, they help familiarize you with your subject.

Sketch of Moonlight and Epona, Pony Mare and Foal

When our small pony, Moonlight, had her foal, I spent many enjoyable hours sketching and photographing them. My favorite kind of sketchbook to use when out in the field is small, pocket-sized and spiral bound because it is easy to carry around and will fold to a flat surface for sketching. I use a pencil or a thin tipped black marker pen to draw with.

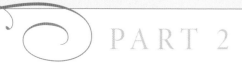
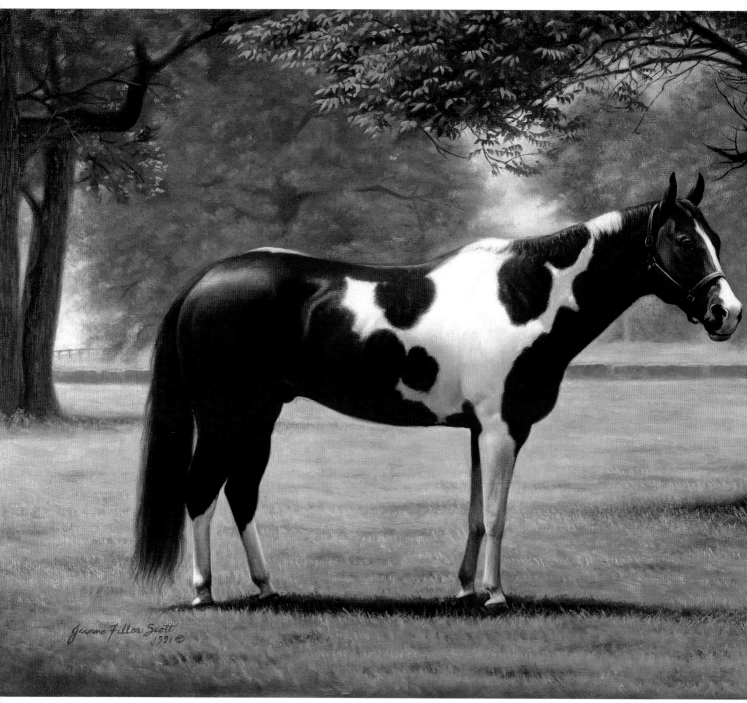

SKY BUG'S LAD
oil on canvas • 22" × 34" (56cm × 86cm) • collection of the Kentucky Horse Park

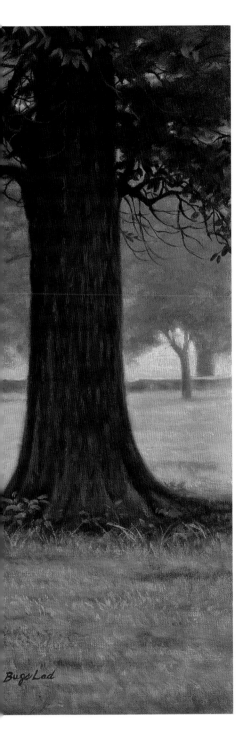

Bugs Lad

Horse Anatomy and Characteristics

The sections in Part 2 focus on some of the basics you will need to know to draw and paint horses that look realistic and lifelike. In the first section, *Drawing the Basic Shapes and Forms,* you will learn about the basic shapes, forms and details that, if depicted convincingly, will make your drawing or painting come alive. The second section, *Getting the Correct Proportions,* takes you through the growth stages of a horse, from a one-day-old foal to six-month-old to yearling to mature horse. You will learn how the proportions change as the horse grows to an adult as well as the differences and similarities between different horse breeds. The last section, *Horse Colors,* gives you an overview of the many different colors of horses: from bay to chestnut, and from paint to gray. You'll also learn how some domestic horses today still show vestiges of the striping patterns of ancestral horses. Once you master these basics, it will be exciting and fun to create your own unique artwork depicting one of the most beautiful animals on the planet.

Head, Profile
Mini Demonstration

This demonstration will familiarize you with how a horse's head looks in profile. Pay special attention to the proportions and to the expression in the eye. While the basic proportions among horses are similar, each individual horse has a different look. For example, a horse may have a longer nose or broader jaw, even within a breed or type. The model for this demo is our family's grade horse Smoky. He was our first horse, and he lived to be over thirty years old. A grade is a horse of mixed-breed ancestry. They can be wonderful companions and riding horses.

MATERIALS

Surface
hot-pressed illustration board

Pencils
no. 2 pencil
ebony pencil

Other Supplies
drawing paper, fine-grade sandpaper, fixative, kneaded eraser, medium tortillion (stump), tracing paper

Sharp or Blunt?

While you need a finely sharpened pencil for most of the drawing, a somewhat blunter point is good for some of the broader areas of shading, such as the neck.

Reference Photo

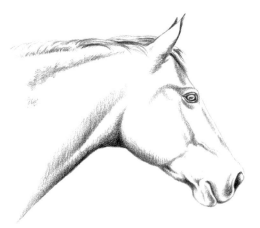

1 Draw the Outline

Lightly draw the outline of the horse's head with a no. 2 pencil on a piece of drawing or printer paper. When you have achieved the correct proportions, use tracing paper to transfer the sketch to a piece of illustration board.

2 Shade In the Darker Values

With an ebony pencil, shade in the darker values. Start with a well-sharpened pencil. As you work, sharpen the point by rubbing it across the sandpaper, then remove the graphite dust by rubbing it on scratch paper. Shade lightly at first, gradually darkening with successive layers. This will help you avoid mistakes that may be difficult to erase.

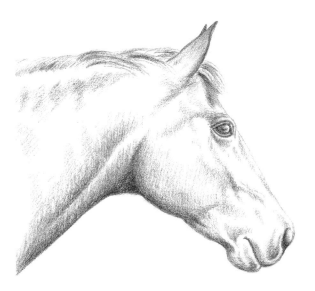

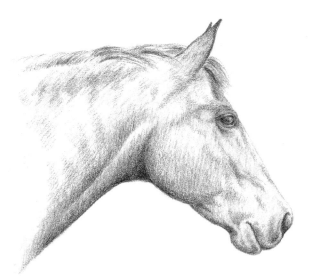

3 Establish the Middle Values

Continue to shade, concentrating on the middle values, with parallel lines that follow the contours. Blend with a medium stump, following the direction of the pencil lines. Blend the middle value areas into the darkest area.

4 Add Lighter Value Detail

Use the stump to blend the middle values and extend them into the white areas to create lighter value tones, leaving the highlights white. Shade with an ebony pencil over the blended areas to create more detail. Reestablish highlights as needed with a kneaded eraser.

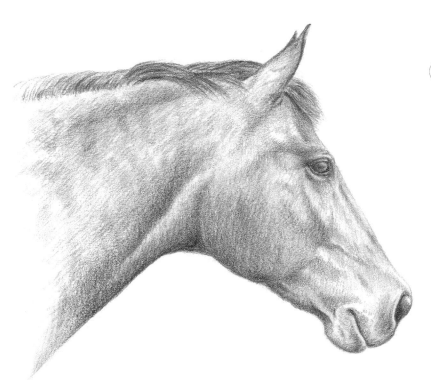

Prevent Smearing

To avoid smearing the drawing, rest your hand on a clean sheet of paper while working. When the drawing is finished, spray it with fixative.

5 Finish the Drawing

Keep shading, using the parallel strokes of an ebony pencil to add the lighter values and details. Lightly blend with the stump. Correct mistakes and lighten areas that have become too dark with a kneaded eraser. Darken the mane, lower neck, throat, jaw and chin.

Head, Front View
Mini Demonstration

Few sights are more appealing than a head-on view of an alert and friendly horse: the pricked ears, the kind eyes and soft muzzle. The model for this drawing was a gray Arabian horse owned by a woman who worked at Wolf Park in Battleground, Indiana. While I was visiting the park to see the wolves, she was nice enough to take me to the stable where she kept her handsome Arabian gelding. This demonstration will familiarize you with the basic forms, how to shade these forms and how to capture the horse's expression.

MATERIALS

Surface
hot-pressed illustration board

Pencils
no. 2 pencil
ebony pencil

Other Supplies
drawing paper, fine-grade sandpaper, fixative, kneaded eraser, medium tortillion (stump), tracing paper

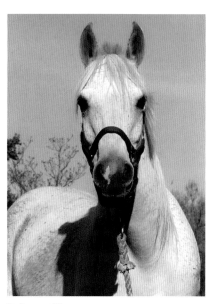

Reference Photo

Try a Stump

You can use a stump to make some of the subtle details, since the stump will probably have graphite from the pencil on it. If there isn't enough graphite on the stump, briefly rub its tip on one of the dark areas of the drawing.

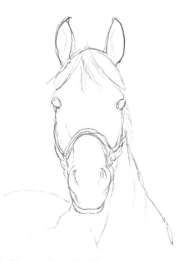

1 Draw the Outline
Draw the outline of the horse's head lightly with a no. 2 pencil on a piece of drawing or printer paper. Use tracing paper to transfer the sketch to the illustration board.

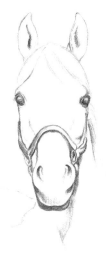

2 Shade In the Darker Values
Use a sharp ebony pencil to start shading in the darker values. You will use this pencil from now on. Shade lightly at first, gradually darkening with successive layers, using parallel strokes that follow the contours of the horse.

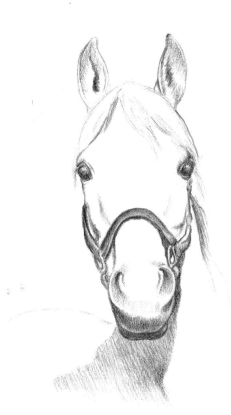

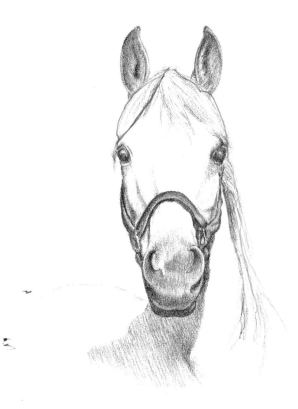

3 Add Middle Values and Blend With Stump

Continue to shade in the darker areas, using a medium stump to blend and add middle values to adjacent areas. Blend in the direction of the pencil strokes. Darken the nostrils, halter and chin.

After blending, use the pencil to shade over the blended areas as needed. Alternate between the pencil and stump to achieve the desired effects.

Shade the neck with light, parallel pencil strokes, using the stump to blend. Add shading to the muzzle, ears and halter.

4 Add the Lighter Values

Shade in the lighter value areas, blending with the stump. Add more detail in the mane, blending with the stump. Darken the ears, alternately using the pencil and stump. Finish the muzzle.

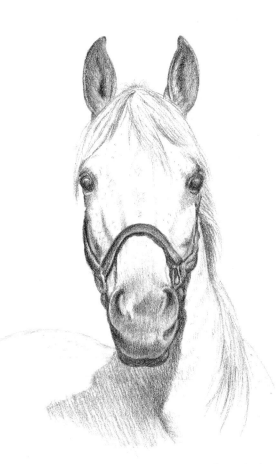

5 Add the Finishing Details

Lightly sketch the freckled areas and other details on the head and neck. Lightly shade the neck, then use a kneaded eraser to lighten or make corrections. Blend with the stump. Add a few more lines of hair detail to the forelock and mane.

Tone down the outer edge of the left nostril and darken the shadow on the neck with the pencil and stump. Lighten the shadow under the left nostril with the kneaded eraser, carefully pressing it onto the surface of the illustration board to lift off the graphite.

Head, Three-Quarter View
Mini Demonstration

The subject of this demonstration is a fine-looking quarter horse I saw at a horse show at the Kentucky Horse Park in Lexington. He has the typical quarter horse head: shorter and wider than that of a Thoroughbred, with a small muzzle and short, alert ears. This horse is wearing a hackamore, a bitless bridle often used by Western riders.

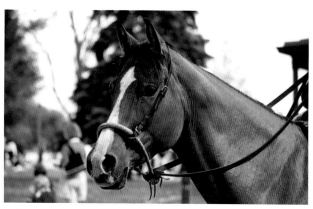

Reference Photo

MATERIALS

Surface
hot-pressed illustration board

Pencils
no. 2 pencil
ebony pencil

Other Supplies
drawing paper, fine-grade sandpaper, fixative, kneaded eraser, medium tortillion (stump), tracing paper

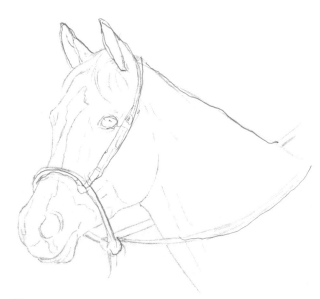

1 Draw the Outline
With a no. 2 pencil, lightly draw the outline of the horse's head on drawing or copy paper. Place the important interior shapes and lines for the eye, nostrils, muscles and bones. Use tracing paper to transfer the drawing to the illustration board.

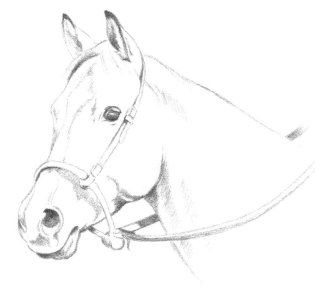

2 Begin to Establish the Darkest Values
Lightly sketch over the drawing's lines with an ebony pencil. Begin to shade in the darkest value areas, starting with a fairly light pressure and gradually increasing the pressure to make it darker. You will darken some of these areas further in the next step. Use light pencil strokes to indicate the major dark areas of shadow and detail.

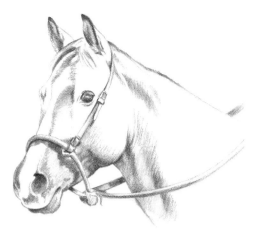

Add Some Life

Even though a highlight doesn't show up in the horse's eye in the reference photo, you can use your artistic license to add a highlight to the eye. This will add life and expression to your drawing.

3 Add More Darks and Begin to Add Midtones

Continue to work on the dark values and start to shade in the midtones. Blend with the stump, extending into the white areas to add some midtones. Shade and blend, using strokes that follow the horse's contours.

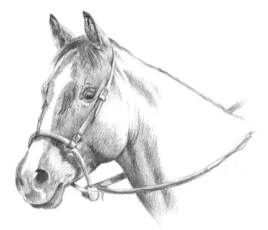

4 Add More Midtones and Detail

Using the pencil and stump, add midtones and detail to the muzzle, face, ears and lower neck. Use crosshatching in the broader areas, such as the cheek. Don't hesitate to further darken areas such as the nostril, ears and lower neck. This will make the drawing "pop out."

Follow the Forms

The horse's hair grows outward in a star pattern, from the center of a horse's forehead, about midway between the eyes and ears. Follow this pattern with your pencil strokes, around the top part of the white blaze on the horse's forehead.

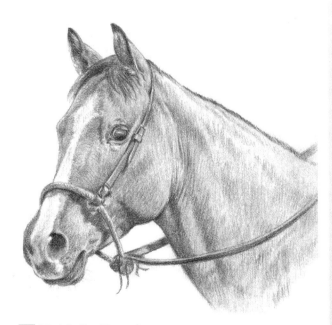

5 Finish the Drawing

Shade the cheek with the pencil and stump. Darken the mane with short pencil strokes. Add line detail to the rope parts of the hackamore with thin, light pencil strokes. Add tassels to the hackamore knot. Sharpen and darken the lower edges of the reins. Use the stump and pencil to finish shading the neck with parallel strokes. Continuing with the stump, add the whiskers and subtle detail to the white blaze.

Hooves

To draw and paint horses realistically, it is necessary to be familiar with the structure and anatomy of the hooves. It's also important to study how the hooves look from different angles, both in action and in repose.

Front Hooves, Side View

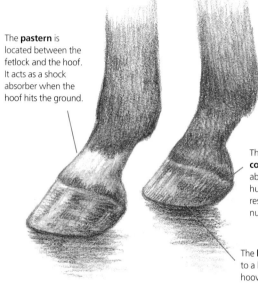

The **pastern** is located between the fetlock and the hoof. It acts as a shock absorber when the hoof hits the ground.

The **fetlock** joint corresponds to the knuckles of a human. The hair tuft on the back of the fetlock is long and shaggy in draft horses, but less noticeable in the lighter breeds.

The **coronary band**, or **coronet**, encircles the foot just above the hoof. Similar to a human's cuticle, the coronet is responsible for the growth and nutrition of the hoof wall.

The **hoof** can be compared to a human's fingernail. The hooves are bell shaped, with the hind hoof having a slightly more pointed toe.

Right Front Hoof, Action Pose

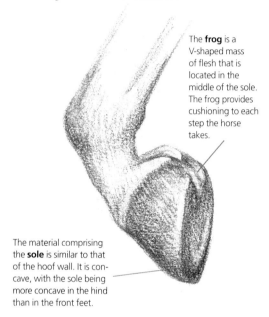

The **frog** is a V-shaped mass of flesh that is located in the middle of the sole. The frog provides cushioning to each step the horse takes.

The material comprising the **sole** is similar to that of the hoof wall. It is concave, with the sole being more concave in the hind than in the front feet.

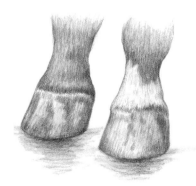

Front Hooves, Three-Quarter View

When drawing or painting the hooves, keep in mind that they are three-dimensional objects. Depending on which way the light is coming from, one side will be darker than the other, and there will be highlights as well as streaks of lighter and darker color on them.

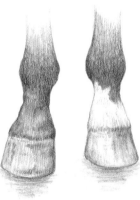

Front Hooves, Front View

Study the hooves so you know what they look like from different angles. This knowledge will help you when you are painting or drawing a horse and the hooves in your reference photo are hidden in the grass. Take close-up photos of horses' hooves from different angles when they are standing on pavement so you'll have them as references when you need them.

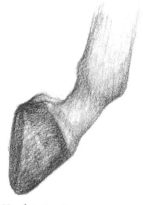

Hind Hoof, Action Pose

Notice how the horse's hoof looks when it is lifted off the ground in mid stride. You can see the elliptical shape of the bottom of the hoof.

Ears

You can tell much about a horse's mood by the position of the ears. An alert horse's ears are pricked and facing forward, while a relaxed horse will carry her ears out to the side. A horse that has one ear facing forward and one ear turned back is listening to a sound that is coming from behind. A frightened or aggressive horse will pin his ears back, parallel to the head.

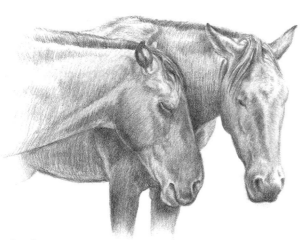

Relaxed

These two mustangs were relaxed and sleepy as they waited to be adopted from the U.S. Bureau of Land Management Wild Horse and Burro Adoption Program at the Kentucky Horse Park. Their ears are flopping out to the side. Notice the other signs that these horses are drowsy: their heads are held low and their eyes are closed.

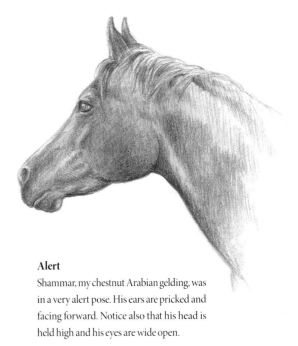

Alert

Shammar, my chestnut Arabian gelding, was in a very alert pose. His ears are pricked and facing forward. Notice also that his head is held high and his eyes are wide open.

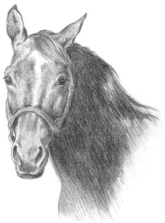

Listening

This Thoroughbred mare's name is Not a Flaw. She was one of three Thoroughbred mares I was commissioned to paint portraits of at Summerhill Farm near Lexington, Kentucky. She has one ear facing to the front and one ear cocked behind, showing that while she is looking at me, she is also listening to something behind her.

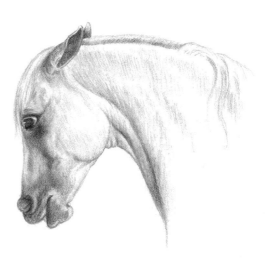

Aggressive

An Egyptian Arabian stallion I saw at the Kentucky Horse Park during the annual Egyptian Event was reacting to other stallions stabled nearby. His body language shows that he feels threatened by the other stallions and is ready to defend his mares and territory. Note the pinned-back ears as well as the arched neck, curled lip, flared nostril and the white of his eye. A horse that is frightened may also have pinned-back ears.

Eye
Mini Demonstration

In this demonstration, you will learn to paint a realistic and lifelike horse's eye. A well-painted eye is the most important key to a horse's expression. The horse who modeled for this demonstration was Abu, an Oldenburg horse I photographed at the Kentucky Horse Park.

Reference Photo

MATERIALS

Surface
hot-pressed illustration board

Acrylic Pigments
Burnt Sienna, Burnt Umber, Cadmium Orange, Raw Sienna, Scarlet Red, Titanium White, Ultramarine Blue

Brushes
nos. 4, 6 rounds

Other Supplies
kneaded eraser, Masterson Sta-Wet Palette, no. 2 pencil, palette knife, paper towels, water jar

Color Mixtures

dark brown

reddish brown

light pink

dark pink

medium brown

blue-gray

eye highlight color

dark reddish brown

light brown

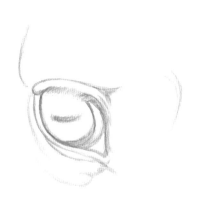

1 Establish the Basic Form
Lightly sketch the eye on the illustration board with a no. 2 pencil. Use Burnt Umber thinned with water and a no. 4 round to paint the main lines of the eye.

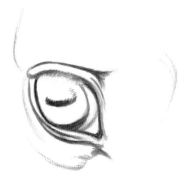

2 Paint the Darkest Values
Use a palette knife to mix Burnt Umber and Ultramarine Blue for the dark brown color. Use a no. 4 round and a small amount of water to paint the darkest areas.

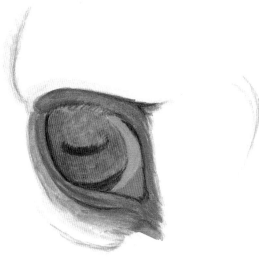

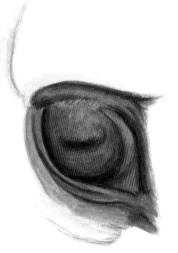

3 Paint the Middle Value Colors

Use a no. 6 round throughout this step. Mix a reddish brown for the iris with Burnt Sienna and Cadmium Orange. Paint the eye with smooth strokes, with enough water to create a thin but not sloppy consistency. Continue layering for richer color. Mix the light pink for the area in front of the iris with Scarlet Red, Raw Sienna and Titanium White. Mix the dark pink for the corner of the eye by adding more Scarlet Red to the mix. Mix the medium brown for the eyelids with Burnt Umber, Raw Sienna, Titanium White and a little Burnt Sienna.

4 Blend and Refine

Using a no. 4 round for the dark brown and a no. 6 round for the reddish brown, paint over the dark brown outer part of the eye, then use the reddish brown to blend where the two colors meet. Use a no. 6 round to apply a glaze of diluted reddish brown over the pink part of the eye. Use the same colors and brushes to darken and blend the pupil with the eye color.

Mixing Perfection

To get just the right color for a small detail, mix two of your color mixtures together with your brush on the palette to create a slightly darker or lighter version of a color.

5 Paint the Finishing Details

Mix a blue-gray for the eyelashes with Titanium White, Ultramarine Blue and Burnt Umber. Paint the lashes with a no. 4 round, using thin strokes. Tone down the base of the eyelashes and add thin, sweeping strokes of dark brown for shadows between the lashes. Mix an eye highlight color with Titanium White, Cadmium Orange and Raw Sienna. Paint the highlight with a no. 6 round, blending the edges with the reddish brown.

With a no. 6 round, mix on the palette a bit of the reddish brown and a bit of the dark brown to create a dark reddish brown. Use this color to blend the dark outer edges of the eye into the adjacent color and darken the corner of the eye.

Mix a light brown highlight color for the eyelids with Titanium White, Raw Sienna and Cadmium Orange. Paint highlights with a no. 4 round, blending with the adjacent medium brown. Reestablish the dark brown folds around the eye as needed.

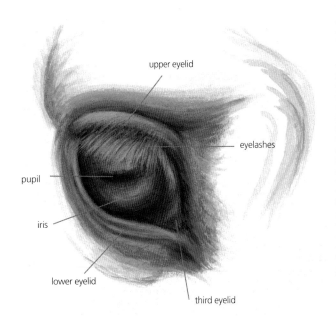

upper eyelid

eyelashes

pupil

iris

lower eyelid

third eyelid

Mane

Mini Demonstration

In this demonstration, you will learn to paint a natural and flowing horse's mane, avoiding the blow-dried, every-hair-in-place look seen in some paintings. The model is a standardbred stallion I saw on a farm near Lexington, Kentucky.

MATERIALS

Surface
hot-pressed illustration board

Acrylic Pigments
Burnt Umber, Cadmium Orange, Raw Sienna, Titanium White, Ultramarine Blue

Brushes
no. 6 round

Other Supplies
kneaded eraser, Masterson Sta-Wet Palette, no. 2 pencil, palette knife, paper towels, water jar

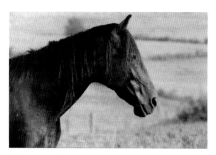

Reference Photo

1 Sketch
Lightly draw the horse's head and mane with a no. 2 pencil.

Color Mixtures

warm black blue-gray

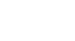

golden brown

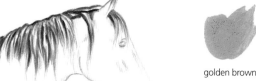

2 Establish the Basic Lines
With a no. 6 round and Burnt Umber thinned with water, paint the basic lines of the mane.

3 Paint the Darkest Values
Mix a warm black with Ultramarine Blue and Burnt Umber for the darkest parts of the mane. Paint with a no. 6 round, using flowing strokes that follow the fall of the mane.

Tail Techniques

Use the same technique to paint a horse's tail. The only difference is that you'll need to paint longer strokes for the long tail hairs.

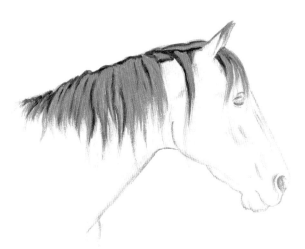

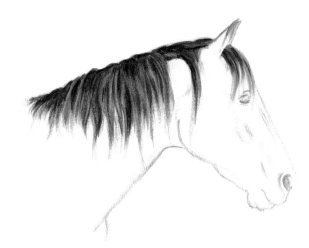

4 Paint the Middle Values

Mix the blue-gray middle values with Titanium White, Ultramarine Blue and Burnt Umber. Paint with a no. 6 round.

5 Add Detail and Reestablish Dark Areas

With the warm black and a no. 6 round, paint detail in the blue-gray areas with flowing strokes. Reestablish the dark areas as needed.

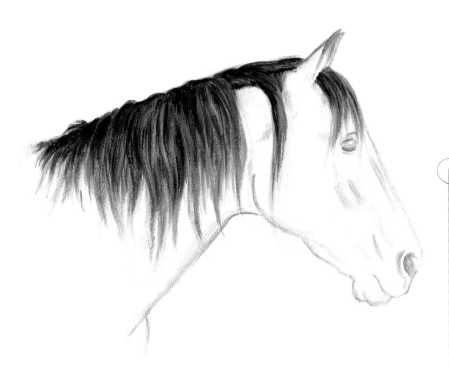

6 Add Highlights and Finishing Details

Mix a golden brown highlight color with Raw Sienna, Titanium White and a little Cadmium Orange. Paint these highlights with a no. 6 round, following the flow of the mane. Add more strokes of blue-gray and warm black to lengthen the mane and add detail.

Mane Highlights

Horses that are kept mainly outdoors in a pasture have manes that are lightened by the sun, especially at the tips of the hairs, just as human hair can become sun streaked. Evening or morning lighting can intensify this effect, seen even on a black mane such as this one.

Structure

In this chapter, you will become acquainted with the basic structure of the horse, including the points of the horse, bone structure and musculature. You will also learn how a horse's proportions change when growing from a foal to an adult horse and the similarities and differences of various breeds of horses.

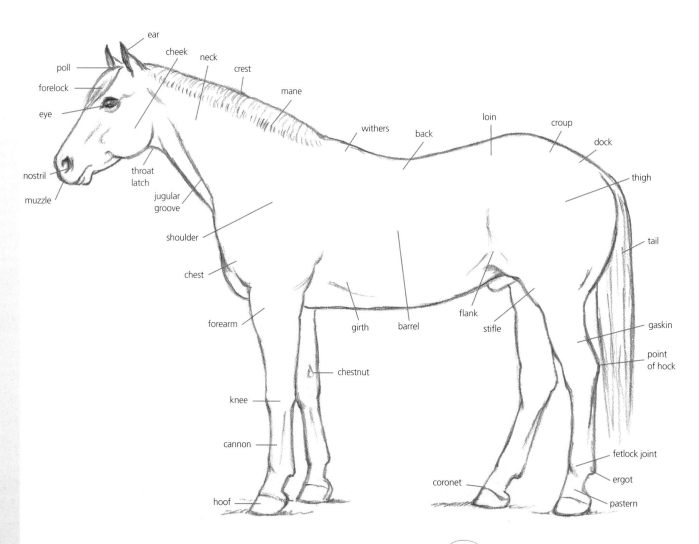

Points of the Horse

The points, or parts, of the horse are the main features of the horse's anatomy. It's a good idea to familiarize yourself with these points so when you are reading that a certain type or breed of horse has a high withers or sloping croup, for example, you'll know what it means.

Model Credits

The model for the drawings on pages 38–39 was the champion paint stallion Titan A Rama from Indian Valley Farm in central Kentucky (see photo of Titan on page 22).

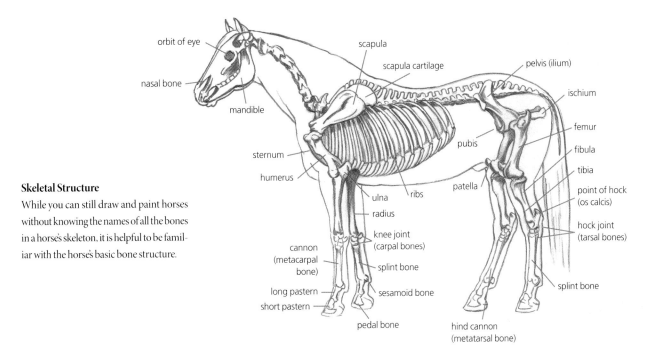

Skeletal Structure

While you can still draw and paint horses without knowing the names of all the bones in a horse's skeleton, it is helpful to be familiar with the horse's basic bone structure.

Labels (skeletal):
orbit of eye, nasal bone, mandible, sternum, humerus, ulna, radius, cannon (metacarpal bone), long pastern, short pastern, pedal bone, knee joint (carpal bones), splint bone, sesamoid bone, scapula, scapula cartilage, ribs, patella, pubis, pelvis (ilium), ischium, femur, fibula, tibia, point of hock (os calcis), hock joint (tarsal bones), splint bone, hind cannon (metatarsal bone)

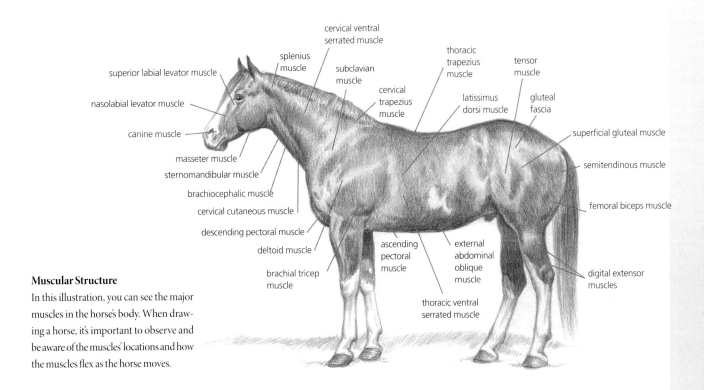

Muscular Structure

In this illustration, you can see the major muscles in the horse's body. When drawing a horse, it's important to observe and be aware of the muscles' locations and how the muscles flex as the horse moves.

Labels (muscular):
superior labial levator muscle, nasolabial levator muscle, canine muscle, masseter muscle, sternomandibular muscle, brachiocephalic muscle, cervical cutaneous muscle, descending pectoral muscle, deltoid muscle, brachial tricep muscle, splenius muscle, cervical ventral serrated muscle, subclavian muscle, cervical trapezius muscle, ascending pectoral muscle, thoracic ventral serrated muscle, thoracic trapezius muscle, latissimus dorsi muscle, external abdominal oblique muscle, tensor muscle, gluteal fascia, superficial gluteal muscle, semitendinous muscle, femoral biceps muscle, digital extensor muscles

Horse Growth Stages

Horses go through many changes as they grow. These drawings show how my Arabian mare Poey grew from a day-old foal to a mature horse. Her registered name is Gilbriar Arapaho, but we call her by her nickname Poey (originally a name I invented for a windup toy dog I had as a child). She is descended from a champion Arabian stallion named Bask, whose bronze likeness graces the foyer of the International Museum of the Horse at the Kentucky Horse Park. I acquired Poey as a foal from an Arabian horse breeder in Oklahoma, who contacted me wanting to expand her art collection (I traded two original paintings for Poey).

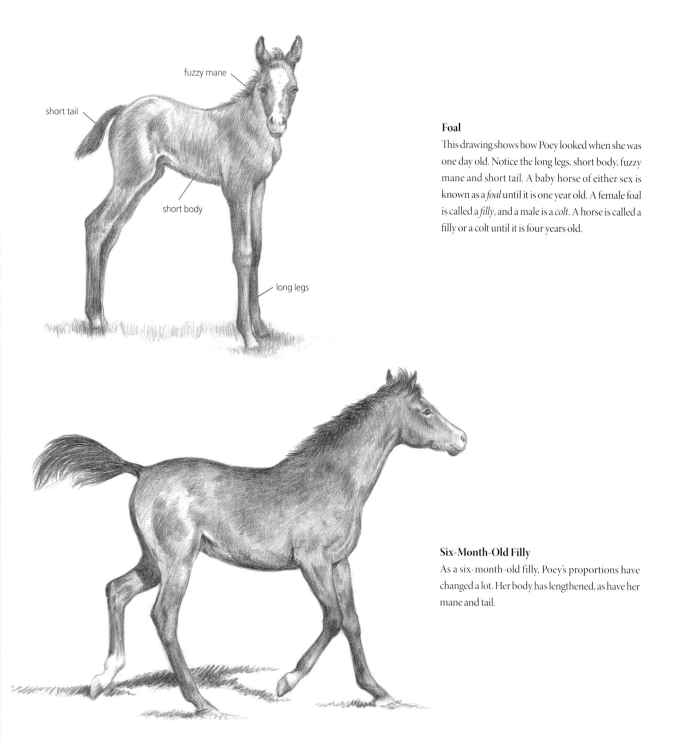

fuzzy mane

short tail

short body

long legs

Foal
This drawing shows how Poey looked when she was one day old. Notice the long legs, short body, fuzzy mane and short tail. A baby horse of either sex is known as a *foal* until it is one year old. A female foal is called a *filly*, and a male is a *colt*. A horse is called a filly or a colt until it is four years old.

Six-Month-Old Filly
As a six-month-old filly, Poey's proportions have changed a lot. Her body has lengthened, as have her mane and tail.

Yearling

At one year of age, Poey's body, head, mane and tail have lengthened farther. She has almost grown into her long legs, and her body has filled out more. A horse of either sex that is between one and two years old is called a *yearling*.

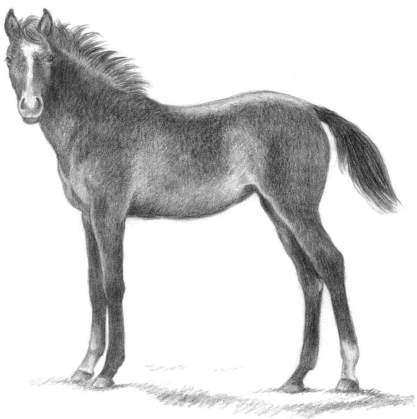

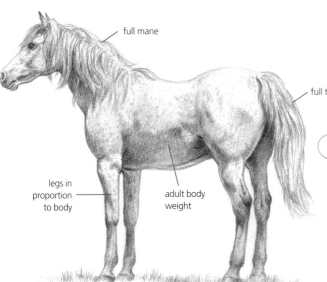

full mane

full tail

legs in proportion to body

adult body weight

Mare

At nine years old, Poey is a mature mare. Most horses reach their adult height and weight by the time they are two years old, although a horse is not considered to be an adult until it reaches the age of four or five. An adult female horse is called a *mare*. A male is either a *stallion* or a *gelding*. A gelding is a male horse that has been neutered to make him easier to handle. Most horses have a life expectancy of twenty-five to thirty years if well cared for, but can live into their midthirties or even longer. The oldest verifiable record was a horse named Old Billy who lived to the age of sixty-two.

A Horse of a Different Color?

Poey is a gray horse. Grays have dark skins with coats that become lighter with age. When Poey was born she was bay colored (reddish brown with a black mane and tail) with a white blaze on her face and two white socks. As she shed her baby hair, she became a dark gray, except for her blaze and socks, and every year thereafter her coat became lighter. She is now what is known as a flea-bitten gray, not completely white, but showing a slight hint of the original base color with speckles of the original reddish brown scattered across the coat. Poey's *dam* (mother) was a gray horse who became almost completely white as she matured, while Poey's *sire* (father) was a bay.

American Saddlebred

The American saddle horse, also known as the American saddlebred, can be chestnut, gray, black or bay in color and stands 15 to 16 hands. The saddlebred was bred by early settlers in Kentucky and is popular as a show horse and for trail riding, and also as a fine harness horse.

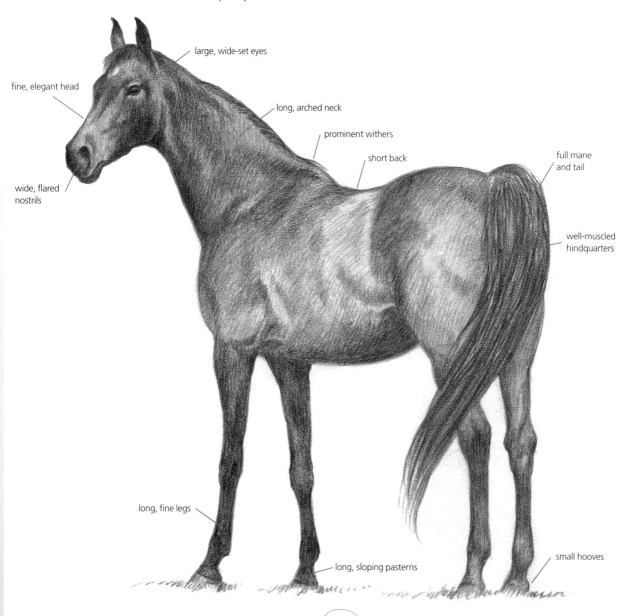

large, wide-set eyes

fine, elegant head

long, arched neck

prominent withers

short back

full mane and tail

wide, flared nostrils

well-muscled hindquarters

long, fine legs

long, sloping pasterns

small hooves

Stylish Elegance

This beautiful horse was turned out in a pasture at the Kentucky Horse Park, but looked as stylish and elegant as if he were in the show ring.

Horse Height Measurement

A horse's height is measured from the top of the shoulders to the ground. The unit of measurement is called a *hand*, which is 4 inches (10cm), and is based on the width of a human hand. A horse that stands 60 inches (152cm) at the shoulder is said to be 15 hands, while a horse that is 62 inches (157cm) tall is said to be 15.2 hands, or 15 hands plus 2 inches (5cm).

Lipizzaner

The Lipizzaner, also known as the Lipizzan, originated in sixteenth century Austria. Most Lipizzaners are born black, gradually lightening with age until almost pure white, but they can be bay, black or roan in color. They stand from 14.2 to 16.1 hands. The Lipizzaner is well known for its association with the Spanish Riding School of Vienna, where stallions are trained for years to perform spectacular maneuvers such as leaping into the air, both with and without a rider. The maneuvers were originally developed by mounted knights to engage ground troops in battle.

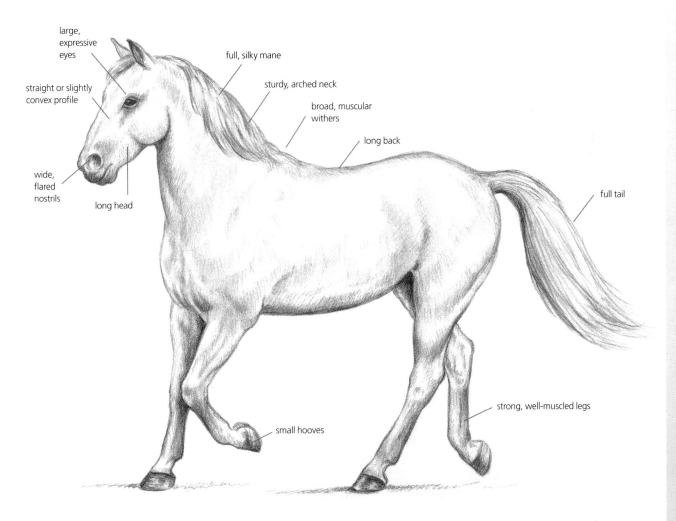

large, expressive eyes

straight or slightly convex profile

full, silky mane

sturdy, arched neck

broad, muscular withers

long back

wide, flared nostrils

long head

full tail

small hooves

strong, well-muscled legs

Magnificent Performer
This magnificent Lipizzaner was performing as part of a world tour with the World Famous Lipizzaner Stallions.

Belgian

The Belgian is descended from the medieval charger, or destrier, ridden by knights. Most Belgians in the United States are a reddish sorrel with a white mane and tail, although Belgians can also be bay, chestnut, dun, roan, gray, brown or black. They are from 15 to 17 hands tall and weigh 2,000 pounds (907kg) or more. The Belgian has a calm, even disposition and is capable of hauling very heavy loads.

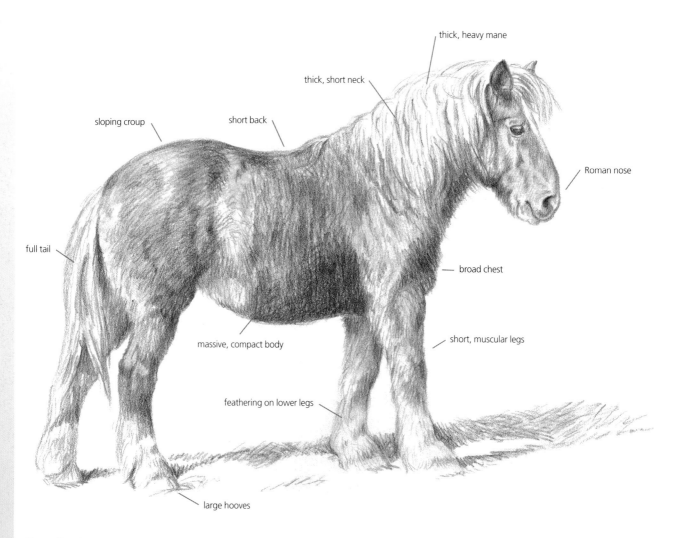

thick, heavy mane

thick, short neck

short back

sloping croup

Roman nose

full tail

broad chest

short, muscular legs

massive, compact body

feathering on lower legs

large hooves

Strong Beauty
The model for this drawing was our strong, beautiful Belgian draft mare, Nelly.

Thoroughbred

The Thoroughbred is the fastest horse in the world, as well as one of the most elegant. The breed was developed in England in the seventeenth and eighteenth centuries by crossing three Arabian stallions, considered to be the founding fathers of the breed—the Godophin Arabian, the Darley Arabian and the Byerly Turk—with English mares. The Thoroughbred can be any solid color, although the most common are brown, bay and chestnut. Their height ranges from 14.2 to over 17 hands, with the average being about 16 hands.

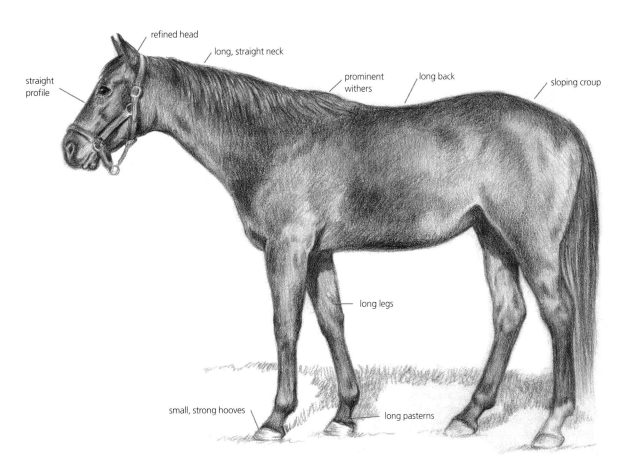

refined head

long, straight neck

straight profile

prominent withers

long back

sloping croup

long legs

small, strong hooves

long pasterns

Fast and Beautiful

The model for this drawing was Win Ticket, a five-year-old racehorse who was retired from racing due to an injury that left him unable to be ridden but with no detectable limp. He can run like the wind! We adopted this beautiful, friendly horse from the Kentucky Equine Humane Center, an organization that helps many horses in need of homes.

Sprinters and Stayers

A Thoroughbred with a sloping croup is likely to be a *sprinter*, a horse that can run very fast over a relatively short distance. A *stayer*, which has a flat croup, is better at winning races over a longer distance.

Pony

A pony is shorter than 14.2 hands at the shoulders. While some horses that are less than 14.2 hands are really just small horses, ponies have a different look from a horse because of their short legs, wide bodies, muscular necks and thick manes and tails. Ponies are tough, having evolved in cold places such as mountains or northern islands, where food and water are scarce. Being both small and short, they could survive in these harsh climates.

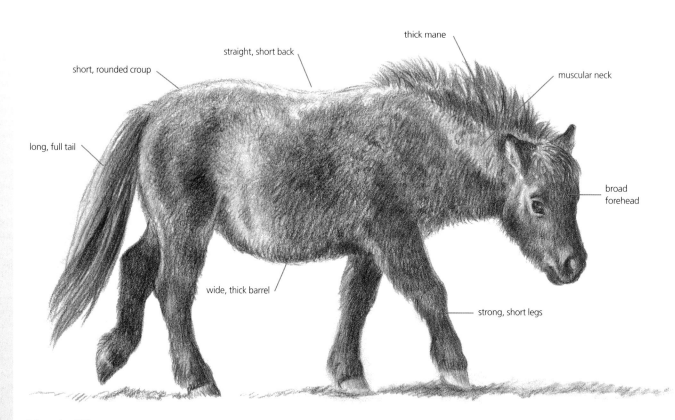

A Surprise Gift
The model for this drawing was our small pony, Epona. She is of indeterminate breed. Her mother, Moonlight, appeared to be a Shetland pony cross, and her father is unknown. When we acquired Moonlight, we had no idea that she was in foal and were thrilled when she gave birth to Epona, who has become a much-loved pet.

Miniature Horse

A miniature horse is shorter than 8.2 hands at the shoulder and weighs from 150 to 250 pounds (68–113kg). Although there are many types and breeds of miniature horses, most breeders of miniatures prefer to produce a tiny horse with the same proportions as a full-size horse. Miniatures can be any color or pattern, including solid colors, paint or Appaloosa spots. Colors that are rare in other breeds, such as dark bodies with white manes and tails, are common in minis. In addition to participating in shows, miniature horses are often kept as pets. They also make fine therapy animals for use with disabled children and adults.

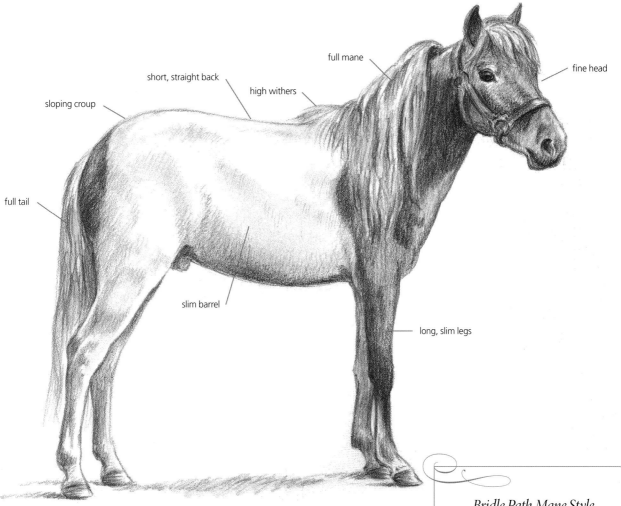

short, straight back

sloping croup

high withers

full mane

fine head

full tail

slim barrel

long, slim legs

Tiny Stallion
The model for this drawing was Frenchie, a miniature horse stallion who obligingly posed for me at the Kentucky Horse Park.

Bridle Path Mane Style

This miniature horse has had his mane cut in what is called the *bridle path style*, where the mane is sheared off from the poll down to about one-third of the neck. The rest of the mane is left natural. This is supposed to prevent hairs from tangling in the bridle and to show off the horse's arching neck.

Arabian

The Arabian originated in the Arabian Peninsula and is one of the oldest horse breeds in the world, dating as far back as 2500 B.C.E. It is part of the ancestry of almost every recognized breed, contributing greatly to the foundation of the Thoroughbred. A beautiful and elegant horse, the Arabian can be black, chestnut, gray, bay and, rarely, roan. Its height is 14 to 15 hands.

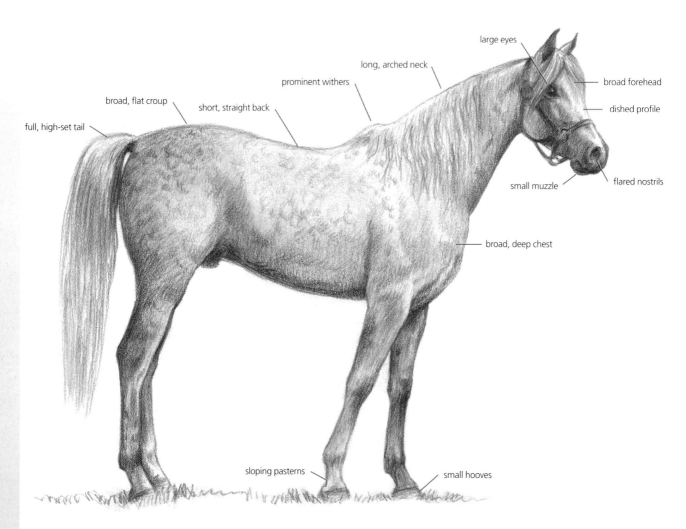

large eyes

long, arched neck

prominent withers

broad forehead

broad, flat croup

dished profile

short, straight back

full, high-set tail

small muzzle

flared nostrils

broad, deep chest

sloping pasterns

small hooves

Egyptian Stallion

This Arabian stallion was at the annual Egyptian Event at the Kentucky Horse Park. Like the miniature horse on page 47, the Arabian had his mane trimmed in the bridle path style.

Friesian

Originating in Holland, the Friesian is one of the oldest breeds in Europe. In the Middle Ages, the Friesian was in demand as a warhorse. Since it is an outstanding trotter, it is often employed as a carriage horse. The Friesian has contributed significantly to the ancestry of all of the competitive trotting breeds. The coat is always black, rarely with a white marking on the head, and the Friesian stands about 15 hands. A Friesian horse was featured prominently in the 1985 film *Ladyhawke*.

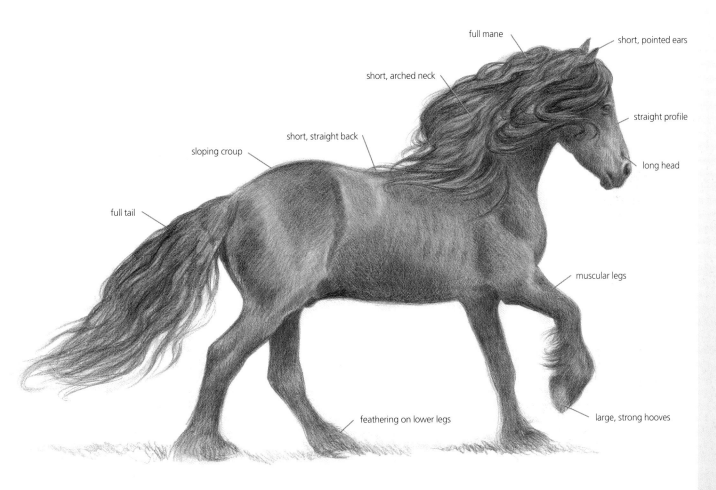

full mane

short, pointed ears

short, arched neck

straight profile

short, straight back

long head

sloping croup

full tail

muscular legs

feathering on lower legs

large, strong hooves

Magnificent Stallion
The subject of this drawing was a magnificent Friesian stallion named Frieske, who resided at the Kentucky Horse Park.

Bay

Horses come in many different colors and coat patterns, and there are numerous shades within each category of color. Also, the coat is longer, thicker and denser in winter but shorter and sleeker in summer, both causing further variations in color and texture. In this section, I'll show you a selection of horse colors and patterns and tell you what colors to mix for painting each horse.

A bay horse has a reddish brown body with black legs, mane and tail. Often the ears are tipped with black and sometimes a black line, called a dorsal stripe, runs the length of the horse's back.

Oil Color Mixtures

red-brown (basic coat color): Burnt Sienna, Cadmium Orange and Yellow Ochre

warm black (mane, tail, legs, ear tips and darker shadows): Burnt Umber and Ultramarine Blue Deep

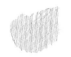

highlight (lightest areas of the coat): Permalba White, Cadmium Orange and Yellow Ochre

dark red-brown (moderately dark shadowed areas of the coat): Burnt Sienna, Cadmium Orange and Ultramarine Blue Deep

blue-gray (highlights on the mane, tail and lower legs): Permalba White, Ultramarine Blue Deep and Burnt Umber

gray (hooves): Permalba White, Raw Sienna and Ultramarine Blue Deep

Bay Pigment Colors
Our grade horse Smoky, who was a beautiful reddish bay in color, is the model for this painting. You'll need the following oil paints to create the bay mixtures: Burnt Sienna, Burnt Umber, Cadmium Orange, Permalba White, Raw Sienna, Ultramarine Blue Deep and Yellow Ochre.

Oil and Acrylic Substitutions

Most paint names are the same in both oil and acrylic. For the colors that are different, you can substitute as follows:

- For Titanium White (acrylic), use Permalba White (oil).
- For Yellow Oxide (acrylic), use Yellow Ochre (oil).
- For Brilliant Orange (acrylic), use Cadmium Orange (oil).
- For Red Oxide (acrylic), use Indian Red (oil).
- For Hansa Yellow Light (acrylic), use Cadmium Yellow Light (oil).
- For Scarlet Red (acrylic), use Cadmium Red Light (oil).

Chestnut

A chestnut horse has a reddish coat, mane and tail, ranging from a dark liver color to blond, which is called sorrel. The mane and tail can be the same color as the coat, or they can be light flaxen in color.

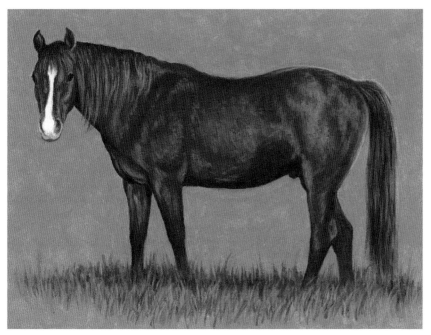

Chestnut Pigment Colors

Shammar, my Arabian horse who lived to be over thirty years old, was the model for the chestnut. He was a rich red chestnut color. Notice the striking white blaze on his face. You'll need the following acrylic paints to create the chestnut mixtures: Burnt Umber, Cadmium Orange, Hansa Yellow Light, Red Oxide, Titanium White, Ultramarine Blue and Yellow Oxide.

Acrylic Color Mixtures

red chestnut (basic coat color): Red Oxide, Burnt Umber and Cadmium Orange

dark chestnut shadow (darkest shadows): Red Oxide, Burnt Umber and Ultramarine Blue

highlight (highlights in the coat): Titanium White with a little Yellow Oxide, Red Oxide and Hansa Yellow Light

middle value coat (for blending where the red chestnut color meets the highlights): mix the red chestnut and highlight colors

warm white (blaze on the face): Titanium White with a touch of Hansa Yellow Light

Gray

Gray horses actually have a mixture of black and white hairs, sometimes with reddish brown hairs mixed in. Most gray horses are born black and gradually lighten with age as white hair replaces the black hair. By the age of ten years, the gray horse appears white, but is distinguished from a true white horse (which has pink skin) by its black skin and the gray around the joints of the legs and feet.

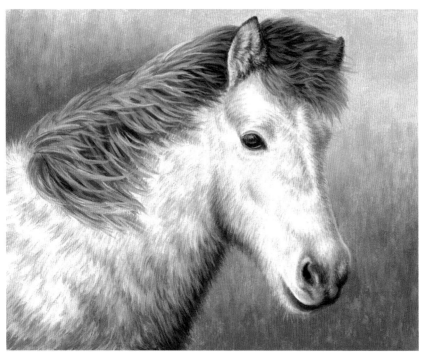

Acrylic Color Mixtures

black (darkest coat and mane, outer lines of the eye, and the nostril and mouth): Burnt Umber and Ultramarine Blue

bluish shadow (shadowed side of the head and coat and mane shadows): Titanium White, Ultramarine Blue and a little Burnt Umber

warm gray (midvalue coat and mane): Burnt Umber, Ultramarine Blue and Titanium White

light gray (details in the lighter areas of the coat and mane): add Titanium White and Yellow Oxide to the warm gray

brown eye (colored part of the eye): Burnt Umber and Yellow Oxide

light buff (warm areas of the coat): Titanium White and Yellow Oxide

highlight (highlights in the coat and mane): add Titanium White to the light buff mix

Gray Pigment Colors

The subject of this painting is an Icelandic pony named Brenna we recently adopted from the Kentucky Equine Humane Center. Due to a leg injury she suffered as a foal, Brenna can never be ridden, but she has only a barely noticeable limp and she gets around very well on our farm. We were very glad to give Brenna a home. She is intelligent and has a pushy but cute personality. Her gray color has a brownish cast due to hairs of that color mixed into the white and black hairs of her coat.

You'll need the following acrylic paints to create the gray mixtures: Burnt Umber, Titanium White, Ultramarine Blue and Yellow Oxide.

Palomino

The palomino has a golden coat with a white or light blond mane and tail. According to the Palomino Registry, the color of the coat is supposed to resemble that of a newly minted U.S. gold coin, and the color can vary from three shades lighter to three shades darker than this. Many different breeds of horses can be palomino in color; about half of all palominos are quarter horses. The quarter horse is a muscular, powerfully built breed of horse that originated in the United States. It is named for the fact that it is such a fast sprinter that no other horse in the world can beat it in a quarter mile race. The quarter horse is used for rounding up cattle, barrel racing, trail riding, polo and show jumping.

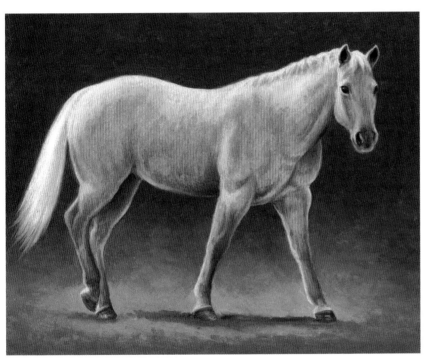

Palomino Pigment Colors
I saw this strong, good-looking palomino quarter horse mare just as the day was beginning at the Kentucky Horse Park. The golden coat and white mane and tail were beautifully lit by the morning light. You'll need the following oil paints to make the palomino mixtures: Burnt Sienna, Burnt Umber, Cadmium Orange, Permalba White, Ultramarine Blue Deep and Yellow Ochre.

Oil Color Mixtures

warm white (mane and tail): Permalba White and a touch of Yellow Ochre

warm brown (shadowed areas of the coat): Burnt Sienna, Burnt Umber and Yellow Ochre

golden (basic coat color and reflected light in the tail): Permalba White, Cadmium Orange, Yellow Ochre and a little Burnt Sienna

highlight (coat highlights): mix Permalba White with the golden mix

warm black (nostrils and muzzle): Burnt Umber and Ultramarine Blue Deep

dark brown (eyes and inside the ears): mix the warm brown and warm black colors

blue-gray (muzzle and hoof highlights, eye glints and mane and tail shadows): Permalba White, Burnt Umber and Ultramarine Blue Deep

gray hooves: add Permalba White and Burnt Sienna to the warm black mix

medium brown (coat details): Burnt Umber, Burnt Sienna, Yellow Ochre and Permalba White

Paint

Paints, also called pintos or spotted horses, have patches of white and another color, such as black or brown. A horse that has black patches is known as a *piebald*, while a horse with any other color patches is called a *skewbald*. A horse that has large patches of more than two colors is called *odd-colored*. Paints can vary from an almost white horse with a few spots of color to a horse that is mostly dark with a few spots of white.

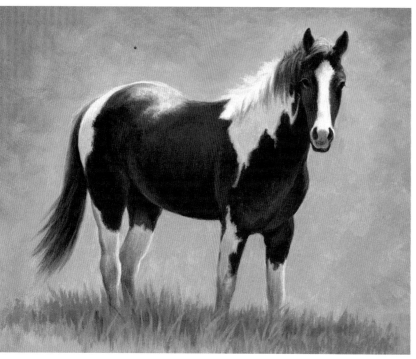

Paint Pigment Colors

I saw this handsome paint while driving along the country roads not far from our farm. I stopped and took a few photos while the horse watched me, curious to see what I was up to. You'll need the following acrylic colors to create the paint horse mixtures: Burnt Sienna, Burnt Umber, Scarlet Red, Titanium White, Ultramarine Blue and Yellow Oxide.

Acrylic Color Mixtures

dark brown (eyes and darkest areas of the coat, mane and tail): Burnt Umber, Burnt Sienna and Ultramarine Blue

reddish brown (coat, mane and tail): Burnt Sienna, Yellow Oxide and a little Titanium White

dark reddish brown (detail in the coat and for blending where the coat color meets the shadowed areas): mix the reddish brown and dark brown colors

bluish shadow (shadowed areas in the white parts of the coat): Titanium White, Ultramarine Blue and a little Burnt Sienna

highlight (reddish parts of the coat): Titanium White, Yellow Oxide and a touch of Burnt Sienna

warm white (highlights on the mane and white parts of the coat): Titanium White and a little Yellow Oxide

pinkish color (muzzle): Scarlet Red, Titanium White and Burnt Sienna

Zebra

The zebra is a wild horse native to Africa. Striping is one of the oldest forms of camouflage and appears to be a part of the color scheme of modern horses' ancestors. Stripes are sometimes found on the legs of domestic horses in breeds such as quarter horses, Connemara ponies and Icelandic ponies. My Arabian horse, Poey, had striping on her legs when she was a foal, which is quite unusual for an Arabian, and I can still see very faint striping on her legs when she has her summer coat.

Other modern day horse colors that harken back to the ancestral horse include dun-colored horses, which have primitive markings such as a dorsal stripe, a dark mask on the face and leg striping, and buckskin-colored horses, which often have dorsal and leg stripes.

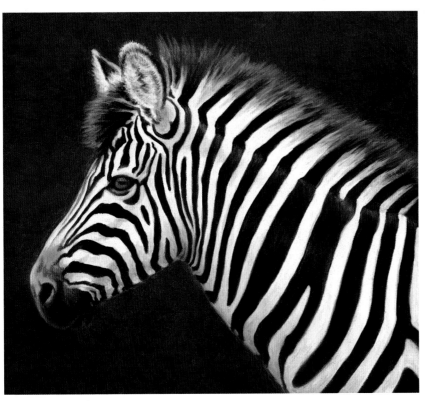

Oil Color Mixtures

warm black (stripes, muzzle, nostril, eye outline and pupil): Burnt Umber and Ultramarine Blue Deep

bluish shadow (shadows in the white part of the coat): Permalba White, Ultramarine Blue Deep and a small amount of Burnt Umber

golden brown (mane fringe, muzzle, inside the ear, and warm reflected light on the head and neck): Permalba White, Burnt Sienna, Yellow Ochre and Cadmium Orange

brown (eye): Burnt Sienna and Yellow Ochre

Zebra Pigment Colors
I observed and photographed this beautiful zebra at the Louisville Zoo. The bold and striking pattern make the zebra an interesting subject to paint, and like fingerprints, no two zebras have exactly the same pattern. You'll need the following oil colors to create the zebra mixtures: Burnt Sienna, Burnt Umber, Cadmium Orange, Permalba White, Ultramarine Blue Deep and Yellow Ochre.

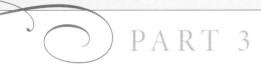
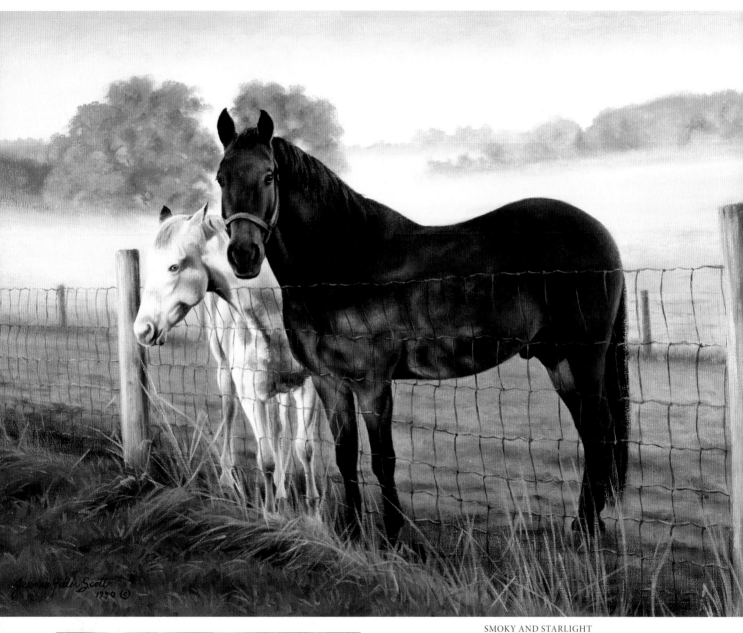

SMOKY AND STARLIGHT
oil on canvas • 18" × 24" (46cm × 61cm) • artist's collection

Conformation Pose

SECRETARIAT
oil on canvas • 18" × 24"
(46cm × 61cm) • private
collection

Horse Portraits

Ever since prehistoric artists drew horses on the walls of caves, horses have been a favorite art subject. There are three basic types of horse portraits: the *conformation pose*, the *classic head portrait* and the *relaxed or informal pose*:

The Conformation Pose

The conformation pose, which is preferred by most horse owners, shows off the horse's anatomy. It is a straight side view, with all four of the horse's legs placed so that there is a clear silhouette of the front and back of the legs up to the knees or hock joints. The head should be up and alert, with the ears pricked.

The Classic Head Portrait

There are three basic angles for the head portrait: profile, full front and three-quarter view. Whatever angle you choose to paint, the horse should look alert and interested, with the ears pricked forward.

The Relaxed Pose

The relaxed or informal pose shows the horse looking natural, as if you had just seen him out in the pasture doing what a horse does when she is free from human restraint. Although I really enjoy drawing and painting horses in all positions, this is my favorite pose.

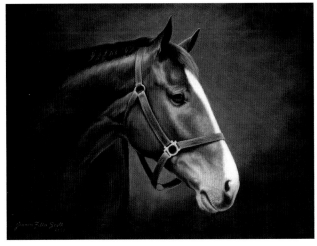

Classic Head Portrait

VASARI
oil on canvas • 18˝ × 24˝ (46cm × 61cm) • private collection

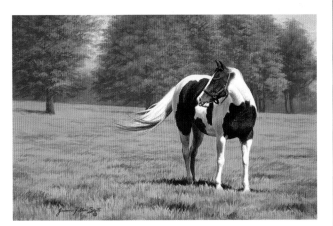

Relaxed Pose

PAINTED LADY
acrylic on panel • 13˝ × 20˝ (33cm × 51cm) • private collection

Thoroughbred in Conformation Pose

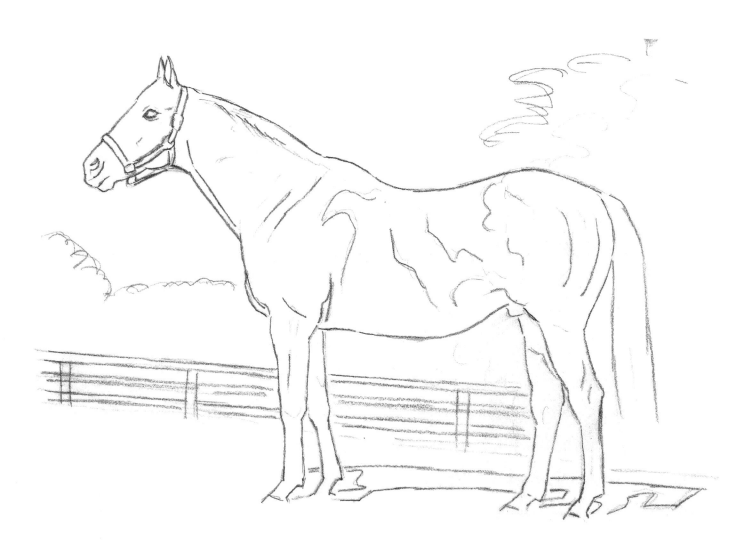

Seattle Slew is one of the most revered of all Thoroughbred racehorses. In 1977, he won the Triple Crown as well as the Eclipse Award as the top three-year-old colt in North America and the Horse of the Year. During his racing career he earned $1,208,726, coming in first in fourteen of seventeen races. As a stallion, Seattle Slew sired over one hundred Stakes-winners. In 1994, I visited Seattle Slew in a private session at his home at Three Chimneys Farm near Lexington, Kentucky.

MATERIALS

Surface
Gessobord panel, 8" × 10" (20cm × 25cm)

Acrylic Pigments
Burnt Sienna, Burnt Umber, Cadmium Orange, Hansa Yellow Light, Hooker's Green, Neutral Gray, value 7.0, Titanium White, Ultramarine Blue, Yellow Oxide

Brushes
nos. 1, 4, 6 rounds
nos. 2, 4, 6, 10 filberts

Reference Photo

Color Mixtures

warm black

dark gray

dark green

middle value green

bluish green

dusty blue

field green

dark field green

dark reddish brown

light brown

green grass

bluish gray

tree highlight

grass highlight

very light brown

1 Establish the Basic Form

With Burnt Umber thinned with water and a no. 6 round, paint the main lines and dark areas of the horse and indicate the main elements of the background. For broader areas of background, use a no. 10 filbert.

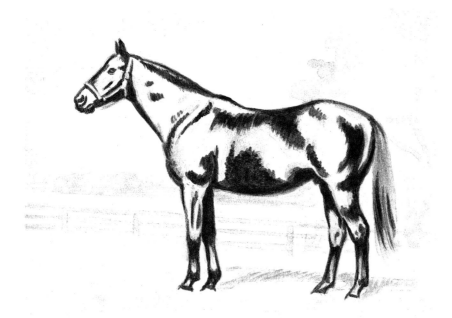

2 Paint the Darkest Value Areas of the Horse

Mix warm black with Burnt Umber and Ultramarine Blue. Paint the darkest areas of the horse with a no. 6 round. For good, dark coverage, add additional paint layers once the first layer is dry. For the smaller detail areas, such as the head and feet, switch to a no. 1 round.

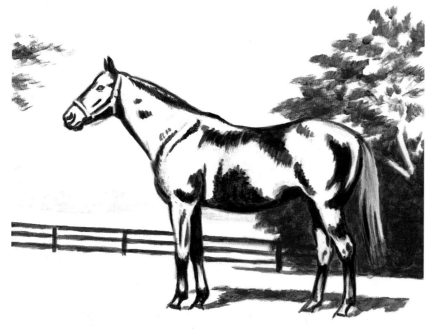

3 Paint Dark Values of the Background

Mix a dark gray for the fence with Burnt Umber, Ultramarine Blue and Titanium White. Paint with a no. 4 round.

Mix dark green for the tree with Hooker's Green, Burnt Umber, Ultramarine Blue and small amounts of Cadmium Orange and Neutral Gray. Use a no. 10 filbert to paint the tree with dabbing strokes. You will paint the lighter values of the tree later. Paint right up to the edge of the horse, eliminating any white space between the horse and background. Use the same brush and color to paint the horse's shadow on the grass.

Atmospheric Perspective

When painting background elements such as trees and fences, always use lighter values than those of the main subject in the foreground. The farther away these objects, the lighter in value they should be. This is called *atmospheric perspective*, and it will give space and depth to your painting.

Sky Tip

Leave some of the white of the panel showing through when you paint the sky. This will give the sky more depth and atmosphere.

4 Paint the Midvalue Landscape Colors

Mix a midvalue green for the tree in the middle distance with Titanium White, Ultramarine Blue and some of the dark green mix. Paint with a no. 2 filbert. Mix a bluish green for the distant tree line with Titanium White, Ultramarine Blue and a smaller portion of dark green. Paint with a no. 2 filbert.

Mix a dusty blue for the sky with Titanium White, Ultramarine Blue and Yellow Oxide. Paint with a no. 4 filbert, using dabbing, semi-circular strokes. Mix a light dusty blue for the horizon line above the tree line with the same colors but add more Titanium White. Paint with a separate no. 4 filbert, blending up into the darker blue.

Mix field green for the distant field with Titanium White, Hooker's Green, Ultramarine Blue and Yellow Oxide. Paint with a

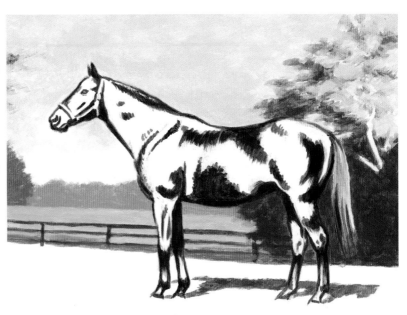

no. 6 round, using sweeping, horizontal strokes. Mix a dark field green by adding some of the dark green mix to some of the field green. Paint the shadowed areas of the field with a no. 6 round.

5 Paint the Midvalue Colors of the Horse and Foreground Grass

Mix the dark reddish brown for the horse's coat with Burnt Umber, Burnt Sienna and small amounts of Titanium White and Ultramarine Blue. Paint the areas of the horse's coat where they transition from the warm black to the highlighted areas with a no. 6 round, using a separate no. 6 round to blend with the warm black. Use smooth strokes that follow the horse's contours. For smaller detail, such as the head, use a no. 1 round. Reestablish warm black areas as needed.

Mix light brown for the halter and lighter parts of the tree trunk with some of the dark reddish brown plus Titanium White. Paint the halter with a no. 1 round and the tree trunk with a no. 6 round. Paint the shadowed part of the tree trunk with warm black.

Mix the green grass color with Hooker's Green, Titanium White, Burnt Sienna and Hansa Yellow Light. Paint with a no. 4 filbert, using a no. 6 round to paint around the horse's legs. Paint with horizontal, dabbing strokes.

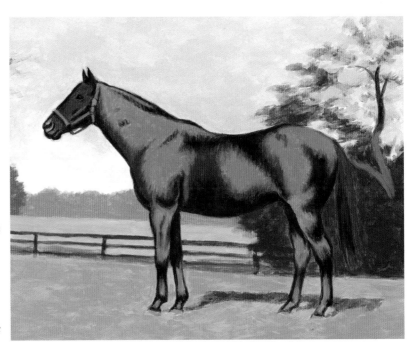

Mix bluish gray for the reflected light on the horse's coat with Titanium White, Ultramarine Blue and small amounts of Burnt Umber and Burnt Sienna. Paint with a no. 6 round, using a no. 1 round for the smaller areas.

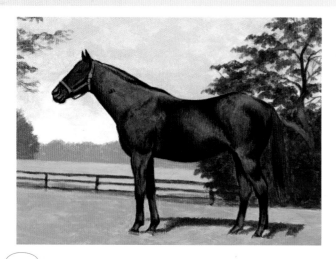

6 Blend the Horse's Coat and Add Detail to the Tree

Paint a glaze of warm black thinned with water over the bluish gray areas of the horse's coat with a no. 6 filbert.

Using a separate no. 6 round for each color, blend where the warm black, reddish brown and bluish gray meet. Use no. 1 rounds for finer areas such as the legs and head. Reestablish dark areas as needed.

With a no. 6 round and dark green, restore the tree foliage that was covered by the sky color. Use dabbing strokes. Paint the thinner branches with warm black and a no. 4 round. Use dark green for the very thin branches. Tone down any leaf clumps that are too dark with the dusty blue sky color. Tone down the tree trunk with a little warm black thinned with water.

Reinforce the horse's shadow in the grass with dark green and a no. 6 round.

Background Advice

When painting a conformation horse portrait, it is important to paint a beautiful landscape as well as a beautiful horse. As an artist, you can manipulate the background so the horse stands out and is complemented by the background.

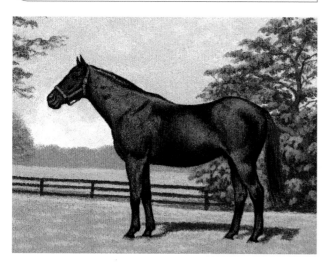

7 Add Detail to Horse and Landscape

With dark gray and a no. 6 round, carefully repaint the fence. Mix a tree highlight color with some of the dark green mixture and some of the green grass color plus Titanium White and Hansa Yellow Light. Use a no. 6 round to paint the leaf clumps with dabbing strokes. Reestablish shadows as needed with the dark green. To create some lighter highlights, use thicker paint, either by using more paint on your brush or adding more paint when the first layer is dry. Use the same brush and color to paint detail on the tree in the middle distance.

With a no. 4 round and warm black, sharpen and refine the horse's outline. Use a separate no. 4 round and the adjacent background color to correct and smooth. Add more dark detail to the horse.

Mix a grass highlight color with some of the tree highlight color plus more Hansa Yellow Light, Titanium White and a little Cadmium Orange. With a no. 6 round, paint small, dabbing, roughly vertical strokes. Use the same brush and color to paint thin sweeping horizontal strokes at the horizon line of the distant field.

Highlights

For brighter highlights, use more paint. Use less paint for more subtle highlights.

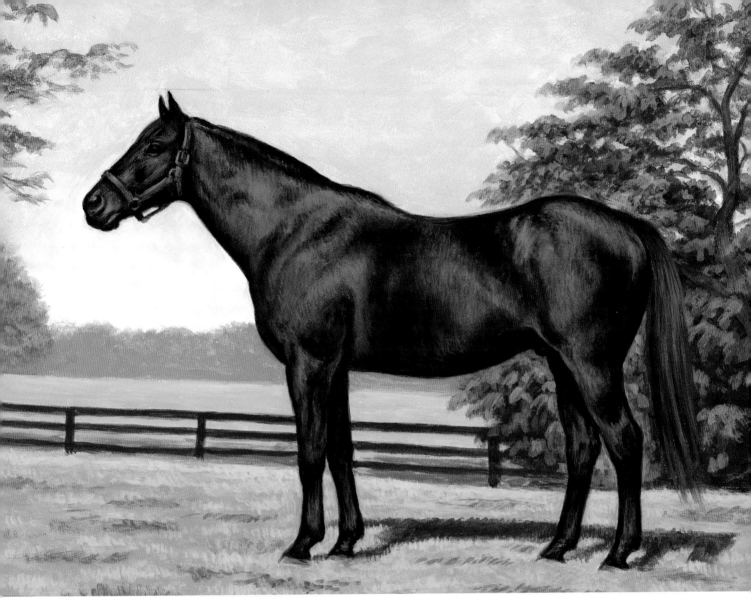

8 Add the Finishing Details

With a no. 6 round for each color, reestablish the highlighted areas of the horse's coat with the bluish gray color. Blend with the adjacent colors, warm black and dark reddish brown. Use a small amount of paint and smooth strokes that follow the horse's contours.

Keep refining the horse's contours and add smaller detail to the muscles. Use a no. 1 round for the head. Darken the halter with a thin diluted layer of dark reddish brown, allowing the color underneath to show through. Paint the metal buckles and rings of the halter with the bluish gray and a no. 1 round.

Mix a very light brown with a bit of the dark reddish brown and Titanium White. Paint highlights on the head, halter and tail, blending as needed with the adjacent color and no. 1 rounds.

With a no. 6 round and the dark reddish brown, add some broken lines to the grass, blending as needed with the grass color. Use dabbing, vertical strokes. This will integrate the horse with the background.

Tone down the tree behind the horse with a thin glaze of dark green and a no. 6 round. Use a separate no. 6 round and the sky color to tone down the outer edges of the tree leaf clumps, using the dry-brush technique (see page 19).

SEATTLE SLEW
acrylic on Gessobord • 8″ × 10″ (20cm × 25cm)

Tree Tip

Trees look more realistic if you paint the outer edges with a slightly lighter value of the same color. This technique was used by the Old Masters.

Thoroughbred in Classic Head Portrait

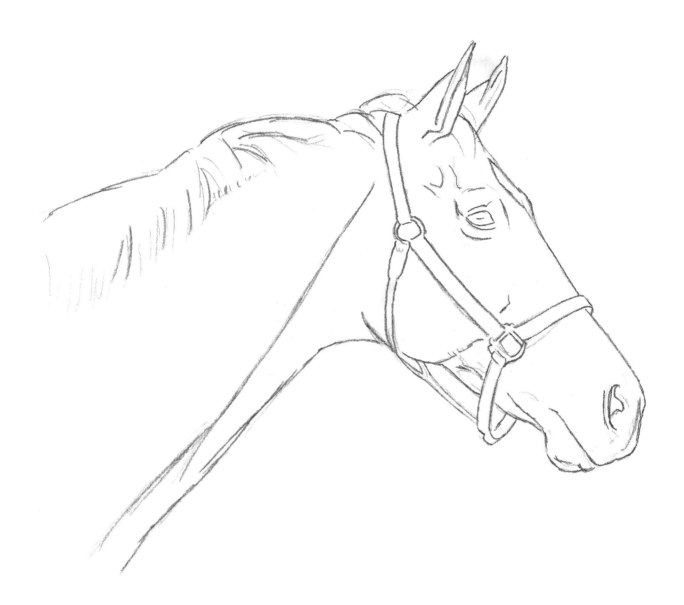

Noble Lady was a thoroughbred mare who resided at Summerhill Farm near Lexington. I was commissioned by her owner to do a color drawing of her and two other mares with their foals. Noble Lady had a beautiful head, and it has been in the back of my mind to do a head portrait of her ever since.

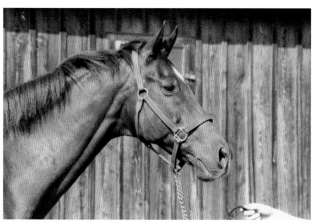

Reference Photo

MATERIALS

Surface
Gessobord panel, 8" × 10" (20cm × 25cm)

Oil Pigments
Burnt Sienna, Burnt Umber, Permalba White, Ultramarine Blue Deep, Yellow Ochre

Brushes
nos. 1, 4, 6 rounds
nos. 4, 10 filberts

Other Supplies
medium, turpentine

Color Mixtures

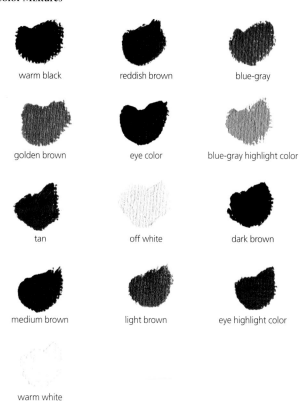

warm black reddish brown blue-gray

golden brown eye color blue-gray highlight color

tan off white dark brown

medium brown light brown eye highlight color

warm white

1 Establish the Form

Use Burnt Umber thinned with turpentine and a no. 6 round to paint the main lines and shading of the horse. Use a no. 1 round for the eye and other smaller details.

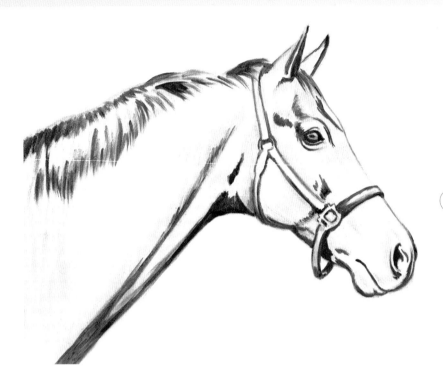

2 Paint the Dark Value Colors

Mix warm black with Burnt Umber and Ultramarine Blue Deep. Paint the darkest areas with a no. 6 round, using a no. 4 round for smaller details.

It's Never Too Late

It isn't uncommon for an artist to forget to paint an essential detail. If you do forget something, you can always add it later!

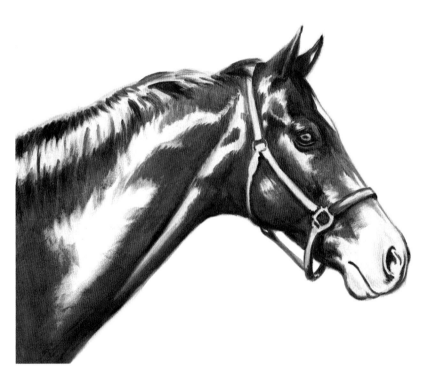

3 Paint Middle Value Colors

Mix the reddish brown color for the horse's coat with Burnt Umber, Burnt Sienna, Yellow Ochre and Ultramarine Blue Deep. Paint with a no. 10 filbert with enough medium so the paint is not too opaque and some of the underlying panel shows through. Switch to a no. 6 round for smaller areas. Use a no. 6 round and warm black to reinforce the dark areas as needed and to blend where it meets the reddish brown. Paint with smooth strokes that follow the horse's contours.

Paint the edges of the reddish brown color thinly with light, feathery strokes into the unpainted white part of the panel so you don't leave a thick edge. This will make it easier to blend the two colors when you paint in the lighter values.

Paint the lower halter strap missed in the first two steps with a no. 4 round and Burnt Umber thinned with medium, then use the warm black to paint the shadowed part of the strap.

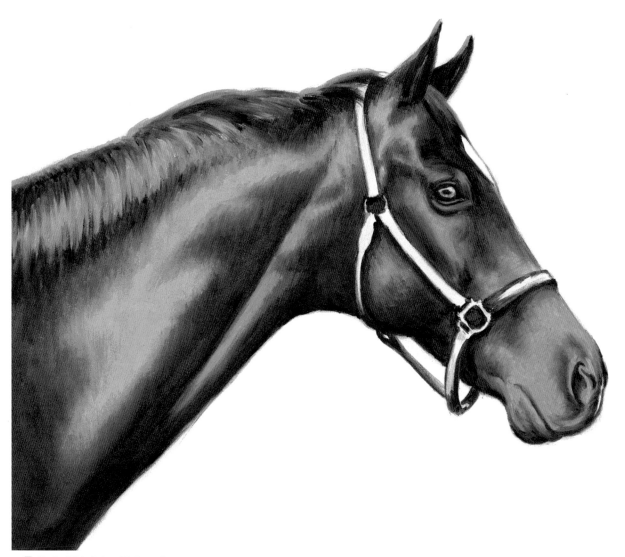

4 Paint Lighter Value Colors

Add some dark detail to the muzzle with a no. 6 round and warm black. For smaller detail, use a no. 4 round.

Mix blue-gray with Permalba White, Ultramarine Blue Deep and Burnt Umber. Paint the muzzle, the highlighted part of the mane, ear tips and around the eyes with a no. 6 round. Using a separate no. 6 round for each color, blend where the blue-gray meets the warm black and reddish brown. For smaller detail, use a no. 4 round.

Mix golden brown with Permalba White, Yellow Ochre and a little Burnt Sienna. Paint the broad area of the neck with a no. 10 filbert, using a no. 6 round for other areas. Blend where the golden brown meets the reddish brown with a separate brush.

Blending Paint

Paint becomes easier to blend as it dries slightly.

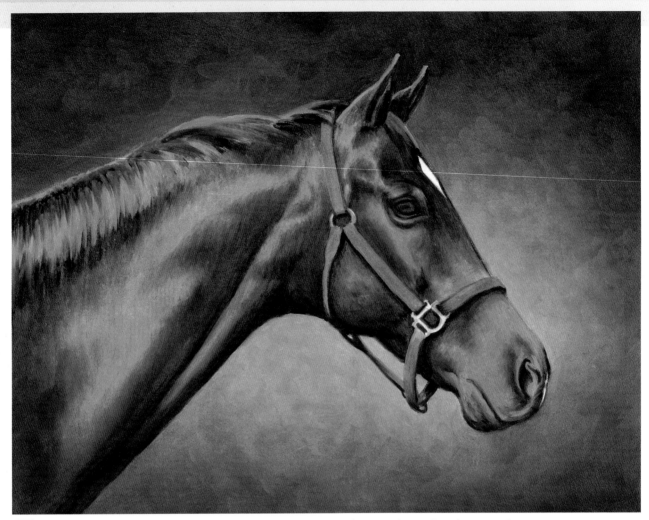

5 Paint the Eye, Halter and Background

Mix the eye color with Burnt Umber, Burnt Sienna and Yellow Ochre. Paint with a no. 4 round, blending the pupil and outline of the eye with a separate no. 4 round and warm black.

Mix a blue-gray highlight color with the blue-gray mix and Permalba White. Use no. 4 rounds to paint highlights on the upper and lower eyelids, blending with blue-gray and warm black to make the eye stand out more.

Mix the tan color for the halter with Burnt Sienna, Burnt Umber, Yellow Ochre and Permalba White. Paint the halter with a no. 6 round. Blend where the warm black shadows meet the tan. Reinforce the shadows as needed.

Mix an off white with Permalba White, some of the blue-gray highlight color and a bit of the tan color. Paint the halter buckles with a no. 4 round.

Mix the three colors for the background. Mix dark brown with Burnt Umber, Burnt Sienna, Yellow Ochre, Permalba White and a small amount of Ultramarine Blue Deep. Paint the upper part of the panel and the lower right corner, near the horse's muzzle, with a no. 4 filbert using dabbing, semicircular strokes. Mix the medium brown with Burnt Sienna, Burnt Umber, Yellow Ochre and Permalba White. Mix the light brown with the same colors but with more Yellow Ochre and Permalba White. Use separate no. 10 filberts to paint around the horse's outline, blending up into the adjacent color. For painting around narrower areas, use no. 6 rounds. Use enough medium so the panel shows through. This will make the background less opaque and more atmospheric.

Reestablish the horse's outline as needed with a no. 6 round and the appropriate color.

Paint a very thin glaze of Burnt Umber and medium, using a very small amount of paint, over the golden brown and blue-gray areas using a no. 4 filbert.

Blending Multiple Colors

When painting and blending two or more colors, hold all of the brushes with the different colors in one hand and use the other hand to paint or blend one color at a time.

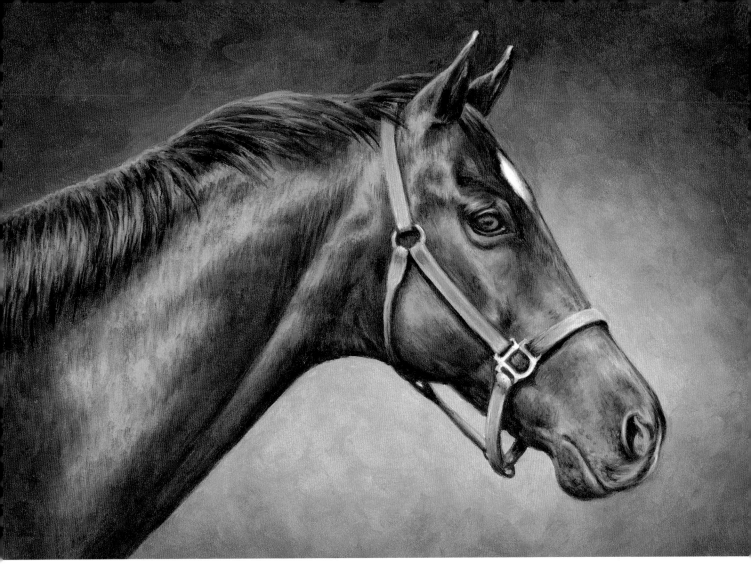

NOBLE LADY
oil on Gessobord • 8" × 10" (20cm × 25cm)

6 Finish the Painting

With a no. 4 filbert, paint a thin glaze of Ultramarine Blue Deep and medium over the reddish brown and blue-gray areas. Use no. 4 rounds to add detail to the muzzle with warm black, blending and softening with the blue-gray. Use a very small amount of paint and light strokes. Reestablish dark shadows as needed with warm black. Use no. 6 rounds to add detail with the reddish brown down into the muzzle area, blending with the blue-gray. Switch to no. 4 rounds for smaller details.

Paint highlights on the eyelids with the blue-gray highlight color and a no. 4 round. Use off white to paint highlights on the halter, ear tips, nostril and other facial features. Paint eyelashes with very delicate stokes of blue-gray with a no. 1 round. Mix the eye highlight color with a bit of the eye color and Permalba White. Carefully paint a small arc of this color in the front part of the eye, blending into the eye color.

Mix warm white for the white markings on the forehead and muzzle with Permalba White and a small amount of Yellow Ochre. Paint with a no. 4 round, blending with the adjacent color. Using no. 4 rounds, paint shadows on the halter with reddish brown and highlights with off white, blending with the tan color.

Blend the broad reddish brown and golden brown areas of the neck with no. 6 filberts. Add detail, blending with the adjacent color. Blend and add detail to the head, switching to no. 6 and no. 4 rounds for the smaller detail. Use a no. 6 round and warm black to paint detail in the mane, blending with the blue-gray.

"Palette-able" Advice

If while mixing colors you run out of room on your palette, prepare a new sheet of palette paper. Take the old sheet off, lay on a flat surface, and replace with the clean sheet. Use your palette knife to transfer each of your colors from the old to the new sheet. You will now have plenty of room to mix more colors.

Appaloosa in Relaxed Pose

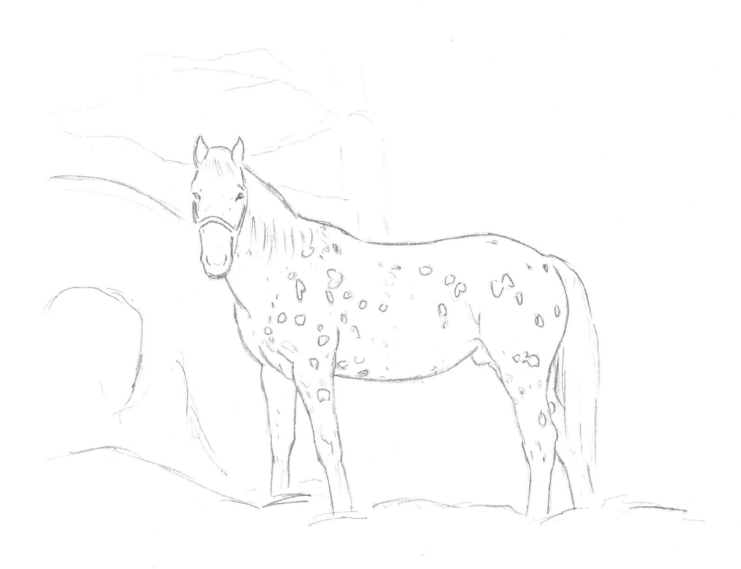

I spotted this handsome leopard Appaloosa, standing next to a hay roll, while I was driving along a gravel road not far from where we live. Impressed by the horse and the composition, I stopped and photographed the scene for future reference.

MATERIALS

Surface
bristol paper, smooth finish

Pencils
no. 2 pencil
ebony pencils

Other Supplies
kneaded eraser, medium tortillions
(stumps), tracing paper (optional)

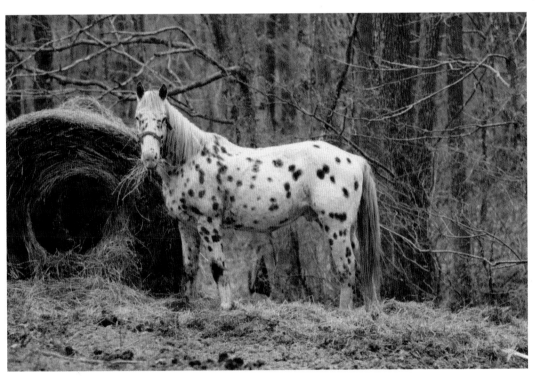

Reference Photo

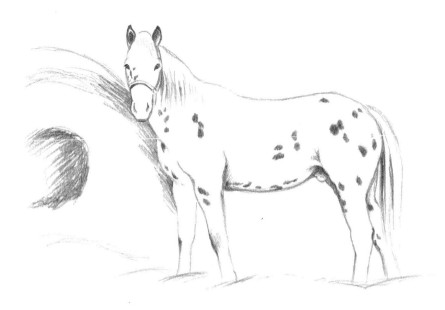

1 Draw the Main Lines

Lightly sketch or trace (see template on page 70) the main lines of the horse and hay roll with a no. 2 pencil. Reinforce the lines with a sharpened ebony pencil. Begin to shade in some of the darker areas.

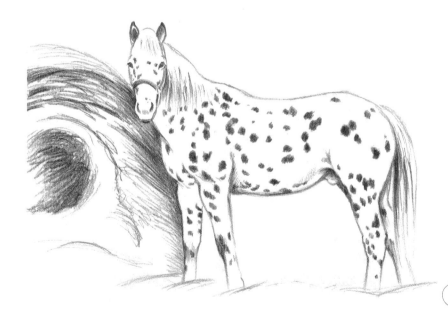

2 Shade In Darker Values

Add more Appaloosa spots to the horse's coat and more shading to the hay. Using an ebony pencil, make short strokes for the spots and long, sweeping strokes for the hay. Add more shading to the horse's body.

Values Hint

To see the dark values more clearly in your reference photo, squint your eyes and the dark values will pop out at you.

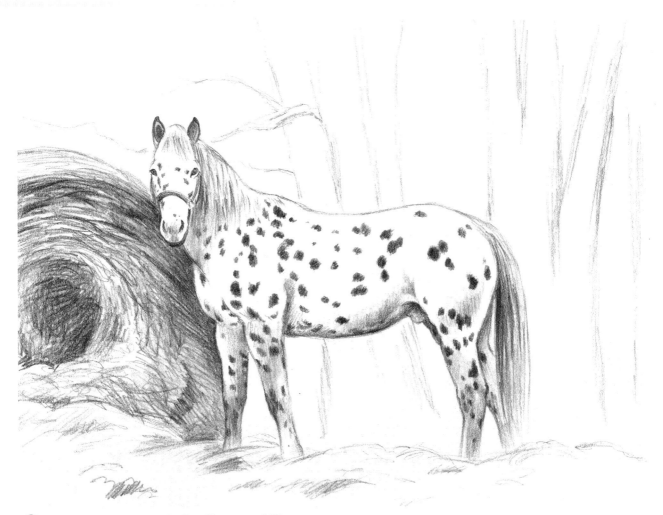

3 Add Middle Values to the Horse and Hay

Shade in some middle value shadow tones and any other Appaloosa spots you missed in Step 2. Begin to use the stump to blend with smooth strokes following the direction of the pencil strokes. Use an ebony pencil throughout this step.

Add detail to the hay roll with pencil strokes that curve in different directions to create the texture. Add shadows and sketchy detail to the hay on the ground. Lightly sketch in the shapes of the trees in the background. Begin to shade in the trees.

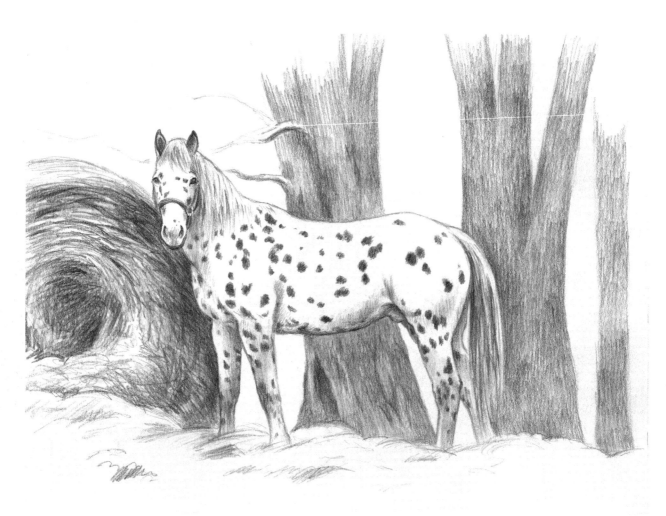

4 Add More Detail

Shade the trees using vertical strokes with a fairly light pressure on the pencil. Gradually darken some of the shadowed areas, but don't make them as dark as the shadows on the horse. This will make the horse stand out against the background.

Use a kneaded eraser to correct any mistakes or to lighten areas that have become too dark. Darken shadows on the horse and the hay roll.

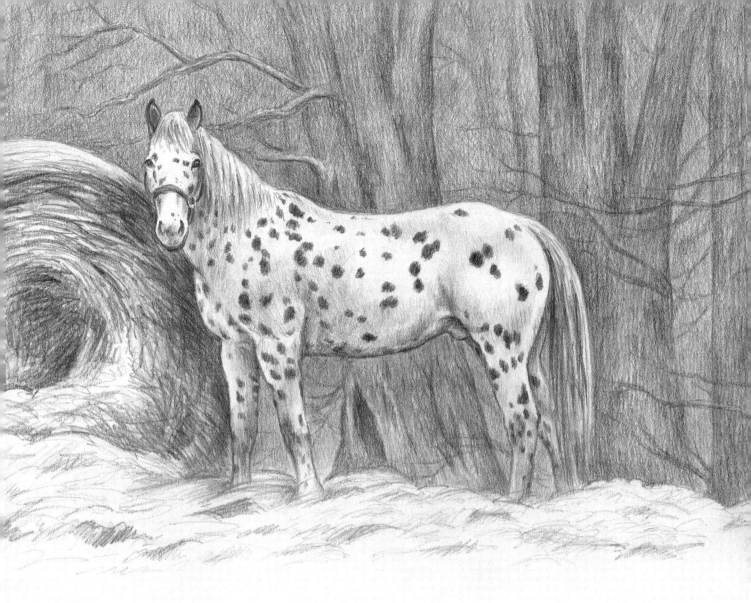

5 Finish the Drawing

Finish shading the tree trunks, then shade lightly between the trees, using parallel strokes. Crosshatch in different directions over the original pencil strokes, then blend with a stump.

Gradually darken the shadows on the tree trunks, then add some shadowy trees in the background. Lightly sketch in some branches.

Add more shading on the horse, using a stump to blend and soften. Make any corrections using a kneaded eraser. Add more detail to the hay in the foreground with sketchy strokes.

LEOPARD APPALOOSA
ebony pencil on bristol paper • 8" × 10" (20cm × 25cm)

Thoroughbred Foal

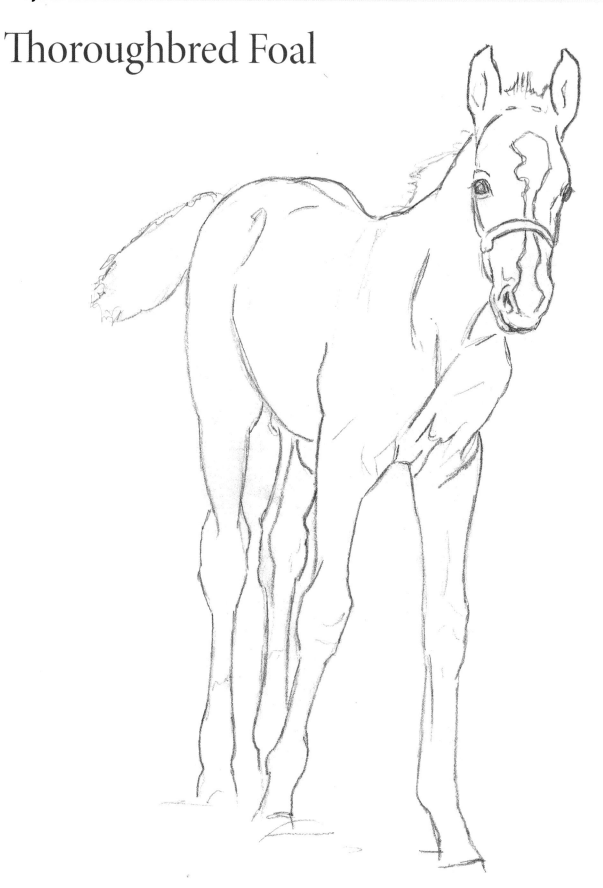

This fine-looking Thoroughbred colt was born at Millford Farm near Midway, Kentucky. I visited the farm because his owner had commissioned me to paint a mare and foal. I had a good time observing and photographing a whole field full of mares and foals!

Reference Photo

MATERIALS

Surface
Gessobord panel, 8" × 10" (20cm × 25cm)

Oil Pigments
Burnt Sienna, Burnt Umber, Cadmium Orange, Cadmium Yellow Light, Cerulean Blue, Naples Yellow, Permalba White, Raw Sienna, Ultramarine Blue Deep, Viridian, Yellow Ochre

Brushes
nos. 1, 4, 6 rounds
nos. 4, 6, 10 filberts

Other Supplies
medium, turpentine

Color Mixtures

warm black

dark red-brown

green tree color

atmospheric blue

sky blue

light sky blue

golden buff

blue-gray

straw shadow

basic straw

green field

bluish shadow

warm white

light brown

tree highlight

grass highlight

coat highlight

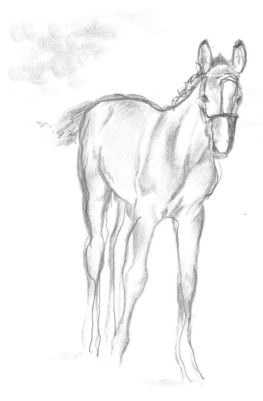

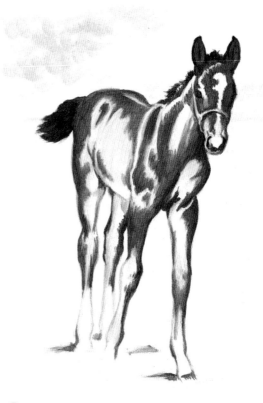

1 Establish the Form

Use Burnt Umber thinned with turpentine to indicate the main lines and shadowed areas of the foal. Use a no. 4 round for detail and a no. 6 round for the broader areas.

2 Paint the Darkest Value Colors

Mix warm black with Burnt Umber and Ultramarine Blue Deep. Paint the darkest areas of the foal with a no. 4 round, using a no. 6 round for the tail. Mix dark red-brown with Burnt Sienna, Cadmium Orange and Ultramarine Blue Deep. Use smooth strokes, following the foal's contours, using no. 4 and no. 6 rounds. Blend where the two colors meet with a separate brush. Use enough medium so the paint flows smoothly and is not too opaque. For broader areas, use a no. 6 filbert.

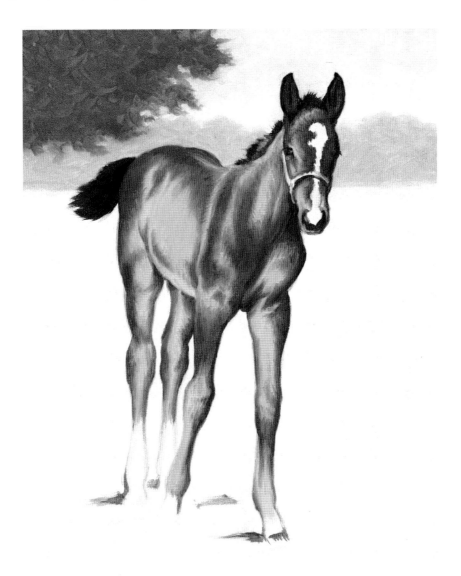

3 Paint Middle Value Colors of Foal and Begin the Background

Mix the green tree color with Viridian, Burnt Umber, Cadmium Orange and Permalba White. Paint the closest tree with a no. 10 filbert, using dabbing, semicircular strokes. Mix the atmospheric blue for the distant tree line with Permalba White, Ultramarine Blue Deep, a little Burnt Umber and some of the green tree color. Paint with a no. 10 filbert with dabbing strokes.

Mix the sky blue color with Permalba White, Cerulean Blue and a little Naples Yellow. Paint with a no. 10 filbert with dabbing strokes, leaving a space above the tree line. Mix a light sky blue color with the sky blue plus Permalba White. Use a separate no. 10 filbert to paint just above the tree line, blending up into the sky blue. Paint around the foal's ears with a no. 6 round.

Use no. 10 filberts to reestablish and lightly blend the near and far trees with the green tree color and atmospheric blue.

Mix the golden buff color for the lighter parts of the foal's coat with Permalba White, Cadmium Orange and Yellow Ochre. Paint with a no. 10 filbert, using a separate no. 10 filbert to lightly blend with dark red-brown where the colors meet. Use no. 6 rounds for smaller areas. Paint with smooth strokes following the foal's contours.

Mix blue-gray with Permalba White, Ultramarine Blue Deep and a small amount of Burnt Umber. Paint the bluish shadows on the foal's hind legs and also around the nostrils with no. 4 rounds. Blend with the adjacent colors. Darken the mane and tail with another layer of warm black, using a no. 4 round.

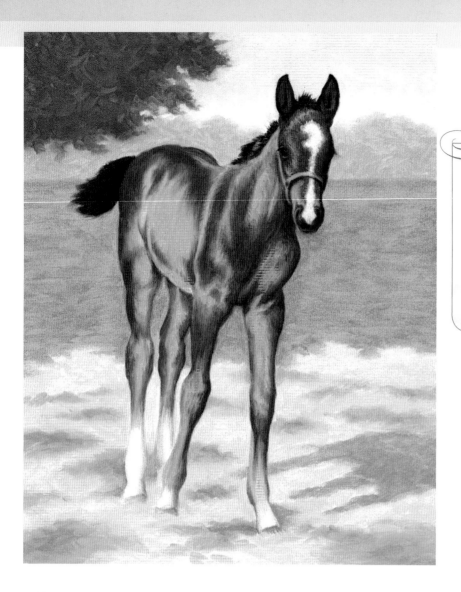

Color Test

When mixing a color, check to see if the color is what you want by dabbing a small amount on your painting. Colors look different on a palette than on your painting. This way, you can make adjustments before committing to the color.

4 Paint the Straw and Field and Add Detail to the Foal

Paint the foal's shadow with the blue-gray color and a no. 10 filbert.

Mix a straw shadow color with Permalba White, Raw Sienna and a little Burnt Umber and Ultramarine Blue Deep. Paint the shadows in the straw with a no. 10 filbert. Mix a straw color with Permalba White, Naples Yellow and a little Raw Sienna. Use a no. 4 filbert to paint the straw, lightly blending the straw shadows into the straw color with a no. 10 filbert. Use a no. 6 round to paint around the foal's legs.

Mix the green field color with Viridian, Permalba White, Naples Yellow and Cadmium Orange. Paint smooth, horizontal strokes with a no. 10 filbert. Use a no. 6 round to paint around the foal's contours.

Mix bluish shadow color with Permalba White, Ultramarine Blue Deep, a little Burnt Umber and a touch of Burnt Sienna. Paint the shadows on the white parts of the legs with a no. 4 round. Blend with the adjacent color.

Use no. 4 rounds to paint the hooves with the dark red-brown for the shadowed parts, blending with the golden buff.

Mix warm white with Permalba White and a little Naples Yellow. Paint the blaze on the face with a no. 4 round, blending the edges with small strokes of the dark red-brown. Use no. 4 rounds to paint the lower part of the muzzle with the bluish shadow color, and add detail to the nostrils, blending with warm black.

Mix light brown for the halter with the straw shadow color and Permalba White. Paint with a no. 1 round. Reinforce the halter shadows with warm black and a no. 1 round.

Paint a thin glaze of dark red-brown over the dark red-brown and golden buff parts of the foal with a no. 10 filbert. Refine the shape of the foal's right eye, then paint a highlight with a bit of the bluish shadow color and a no. 1 round. Let dry.

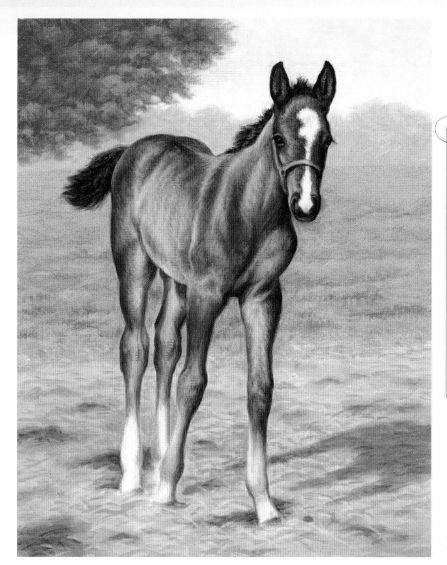

Retouch Varnish

Oil painting will lose its sheen and the colors will become dull as they dry. Use a spray damar retouch varnish to lightly spray the painting before you begin to work on it again. It takes only a few minutes for the varnish to dry. This restores the colors so they look the same as when you applied them, and will ensure that the colors you use in a new painting session will match the colors from the previous painting session.

A FINE LOOKING COLT
oil on Gessobord • 8" × 10" (20cm × 25cm)

5 Finish the Painting

Use a no. 4 round and dark red-brown to paint lightly over the golden buff areas of the coat. Darken the shadows on the hind legs with warm black, blending with blue-gray.

Paint a thin glaze of medium and Burnt Umber over the straw with a no. 4 filbert. Mix a tree highlight color with the green field color, Permalba White and Cadmium Yellow Light. Dab with a no. 6 filbert, blending lightly with the green tree color. Soften the edges of the tree with feathery strokes.

Paint shadows in the field with no. 6 filberts and the green tree color. Mix a grass highlight color with a portion of the green field color plus more Permalba White and Cadmium Yellow Light. With a no. 6 filbert, paint highlights. Use no. 6 filberts to paint vertical strokes of the green tree color and grass highlight color.

Paint detail in the straw with the straw shadow color and a no. 4 round. Use a separate no. 4 round with the dark red-brown to paint darker strokes in the shadowed areas. Use the straw shadow color and blue-gray to soften and blend.

Mix the coat highlight color with Permalba White, Cadmium Yellow Light and Yellow Ochre. Paint highlights on the coat with a no. 4 round, blending with the adjacent color and using separate no. 4 rounds. Add detail to the dark red-brown areas of the coat with the golden buff.

Paint highlights in the tail with blue-gray and a no. 4 round, blending with warm black. Define the left eye with blue-gray and a no. 1 round. Paint a highlight in the eye. Use warm black with a no. 4 round to darken shadows on the foal.

Paint a glaze of Ultramarine Blue Deep over the foal's shadow with a no. 6 filbert, then darken the shadows in the straw. Blend the shadow edges with a bit of blue-gray.

With the coat highlight color and a no. 4 round, add a few strokes in the straw around the foal's feet.

Paint Foal

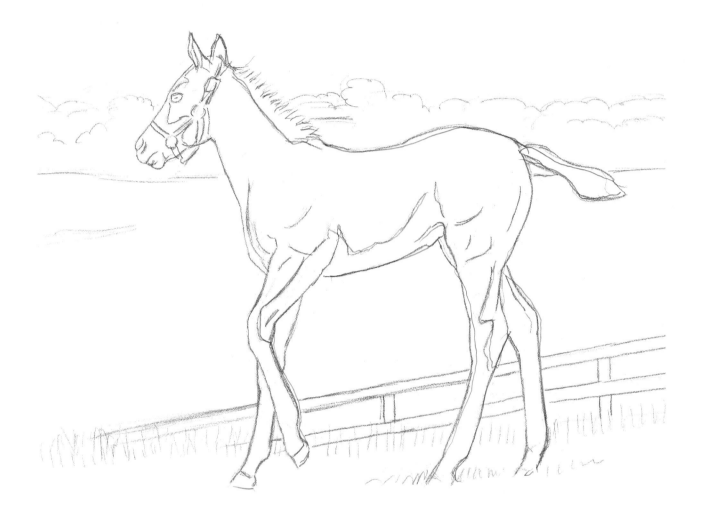

Several years ago, I was invited to Indian Valley Farm in central Kentucky, to see the paint horses they raised there. I was particularly impressed by this lovely paint filly. She looked so proud and alert as she cavorted through the field. She had one blue and one brown eye.

MATERIALS

Surface
Gessobord panel, 8" × 10" (20cm × 25cm)

Acrylic Pigments
Burnt Umber, Cadmium Orange, Cerulean Blue, Hansa Yellow Light, Hooker's Green, Naples Yellow, Red Oxide, Scarlet Red, Titanium White, Ultramarine Blue, Yellow Oxide

Brushes
nos. 1, 4, 6 rounds
nos. 4, 10 filberts

Other Supplies
paper towels, water

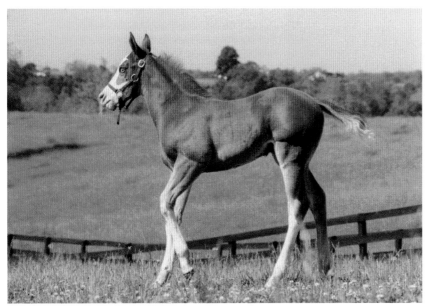

Reference Photo

Color Mixtures

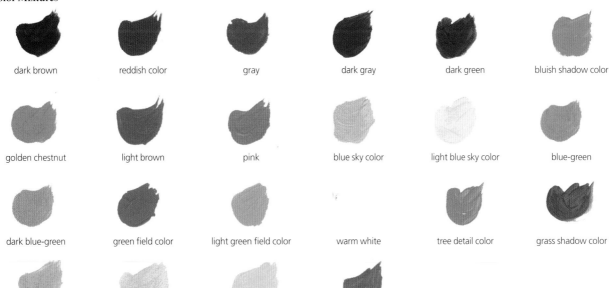

dark brown	reddish color	gray	dark gray	dark green	bluish shadow color
golden chestnut	light brown	pink	blue sky color	light blue sky color	blue-green
dark blue-green	green field color	light green field color	warm white	tree detail color	grass shadow color
field highlight color	grass highlight color	chestnut highlight color	brownish color		

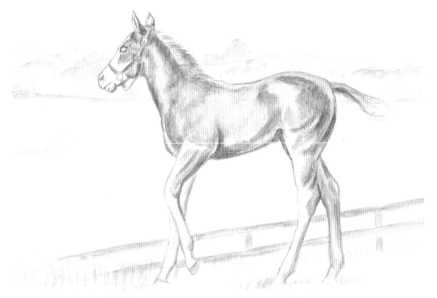

1 Establish the Form

With Burnt Umber thinned with water, paint the basic form. Use a no. 4 round, switching to a no. 6 round for broader areas of the foal and for the landscape.

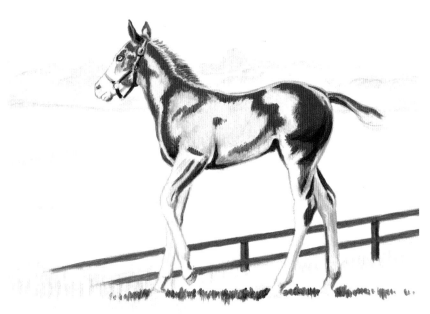

2 Paint the Darkest Value Colors of the Foal and the Fence

Mix dark brown with Burnt Umber and Ultramarine Blue. Paint the dark shadows on the foal with a no. 4 round.

Mix the reddish color with Red Oxide, Burnt Umber and Cadmium Orange. Paint with a no. 6 round, using a no. 4 round for smaller areas. For better coverage, let the first coat dry and paint additional layers.

Mix gray for the fence with Burnt Umber, Ultramarine Blue and Titanium White. Paint carefully with a no. 4 round, using long, parallel strokes. Don't worry about getting it perfectly straight, as you will refine it as you paint the landscape around it.

Mix dark gray for the shadowed parts of the fence posts with some of the gray mixed with some of the dark brown. Paint with a no. 4 round.

Mix dark green for the foal's shadow in the grass with Hooker's Green, Ultramarine Blue, Burnt Umber and Cadmium Orange. Paint with a no. 6 round, using uneven vertical strokes.

Distant Fence

Although the fence is black, it needs to be lighter in value than the darkest parts of the foal so it will recede into the background and appear to be farther away.

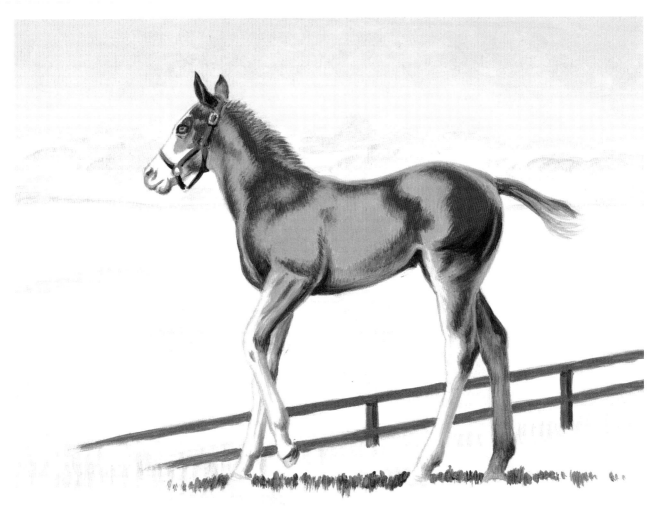

3 Paint the Midvalue Colors of the Foal's Coat and the Sky

Mix the bluish shadow color with Titanium White, Ultramarine Blue, Burnt Umber and a touch of Red Oxide. Paint the shadowed areas on the lighter parts of the foal, including the legs, head, neck, belly, hindquarters and tail, with a no. 4 round. Blend with the adjacent color, using a separate no. 4 round. Add darker detail to the legs and belly with the reddish color and the dark brown using no. 4 rounds, blending as you paint.

Paint the foal's blue eye with a no. 1 round and the bluish shadow color, reestablishing the pupil with dark brown and a separate no. 1 round.

Mix the golden chestnut color with some of the reddish color plus Titanium White and Yellow Oxide. Paint the midvalue areas of the coat with a no. 6 round. Begin to blend where it meets the reddish color with a separate no. 6 round. Use no. 4 rounds for smaller areas such as the head and mane.

Mix light brown for the halter with Titanium White, Burnt Umber and Yellow Oxide. Paint with a no. 4 round.

Mix the pink color for the muzzle with Titanium White, Scarlet Red and Burnt Umber. Paint with a no. 4 round, using a separate no. 4 round to blend with the dark brown.

Mix the blue sky color with Cerulean Blue, Titanium White and a touch of Naples Yellow. Mix a light blue sky color by adding more Titanium White to the mix. With dabbing strokes, use the lighter mix to paint just above the horizon line, using a separate no. 10 filbert to paint the blue sky color. Blend the colors into each other where they meet. Use no. 6 rounds to paint around the foal's head and neck. Add a second coat of paint for better coverage.

Wet Paint!

If your paint is too wet, blot your brush on a paper towel before painting.

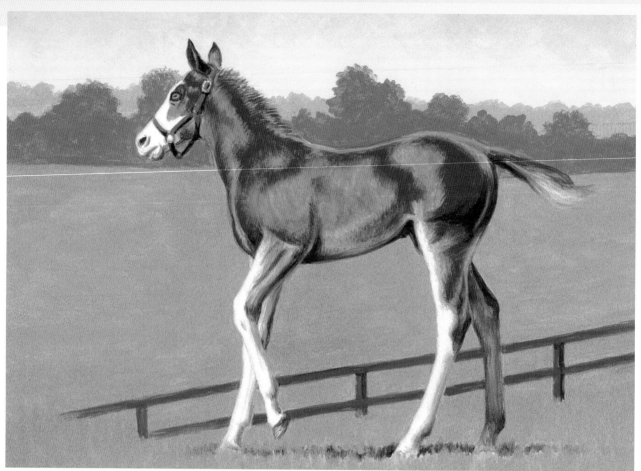

4 Paint the Landscape and the White Areas of the Foal

Mix the blue-green for the most distant trees with Titanium White, Hooker's Green, Ultramarine Blue and a little Burnt Umber. Paint dabbing strokes with a no. 6 round.

Mix the dark blue-green for the closer trees with the same colors but with less Titanium White and the addition of a little Cadmium Orange. Paint dabbing strokes with a no. 6 round. Paint around the foal with a no. 4 round.

Mix the green field color with Hooker's Green, Titanium White, Ultramarine Blue, Yellow Oxide and a little Burnt Umber. Paint sweeping horizontal strokes with a no. 4 filbert. Use a no. 6 round to paint around the fence and foal. Use the same color and a no. 4 filbert to paint the foreground grass with roughly vertical, dabbing strokes.

Mix a light green field color for the distant fields between the tree lines with a portion of the green field color plus more Titanium White and Yellow Oxide. Paint with a no. 4 round. Refine and reestablish the outlines of the foal and fence as needed with no. 4 rounds and the appropriate color. Use the field green and a no. 4 round to correct and further refine the outlines.

Paint a thin glaze of the reddish color and water over the golden chestnut parts of the foal's coat, wiping quickly with a paper towel if it gets too dark.

Mix warm white with Titanium White and a touch of Hansa Yellow Light. Paint the white areas of the foal with a no. 4 round, blending with the adjacent color.

Artistic License

As an artist, it's your right to manipulate the background in order to enhance the main subject. I made one of the trees in the background taller to make the foal's white face stand out more.

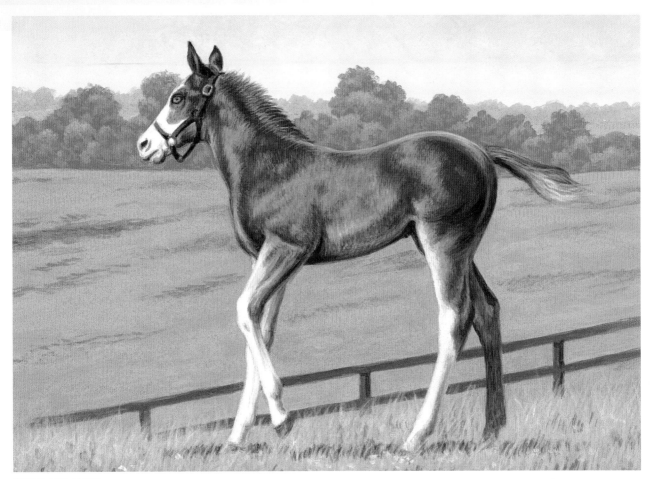

PROUD AND ALERT
acrylic on Gessobord • 8" × 10" (20cm × 25cm)

5 Add Detail to the Foal and Landscape

Mix a tree detail color for the closest row of trees with the dark blue-green plus more Titanium White and Yellow Oxide. Use a no. 4 round to paint clumps of foliage with light dabbing strokes.

Mix a grass shadow color for the field with a mix of the dark green and the green field color. Use a no. 6 round to paint the shadows in the field with sketchy strokes. Tone down any that are too dark with the green field color.

Mix a field highlight color with the green field color plus Hansa Yellow Light. Use a no. 6 round with light horizontal strokes near the horizon. Use dabbing strokes closer to the foreground. Blend with the green field color.

Reinforce the foal's shadow in the grass with the dark green and a no. 6 round. Add some shadows to the grass in the foreground with dabbing strokes. Break up these shadows with some strokes of the green field color.

Mix a grass highlight color with some of the warm white and field green plus Hansa Yellow Light. Using a no. 6 round, paint sweeping, roughly vertical, curving strokes of grass on the hillock where the foal is standing.

Extend the top board of the fence to the left with gray and a no. 6 round. With a no. 4 round and the field highlight color, add highlights to the trees.

Add detail to the lighter parts of the foal's coat with the reddish color and a no. 6 round. Use dark brown to add detail and darken shadows on the foal.

Mix the chestnut highlight color with some of the golden chestnut color plus Titanium White. Paint highlights on the foal with a no. 6 round for broader areas, and a no. 4 round for smaller detail. Use a small amount of paint with small strokes. Paint the halter buckle with a no. 4 round.

Make a brownish color for the grass with a mix of the reddish color and the golden chestnut. Paint random strokes with a no. 4 round. Dab in clover flowers with warm white. Add strokes of warm white and grass highlight color.

Refine the eye with no. 1 rounds and warm black. Paint the upper eyelid, and smooth and reduce the thickness of the eye outline.

Quarter Horse Foal

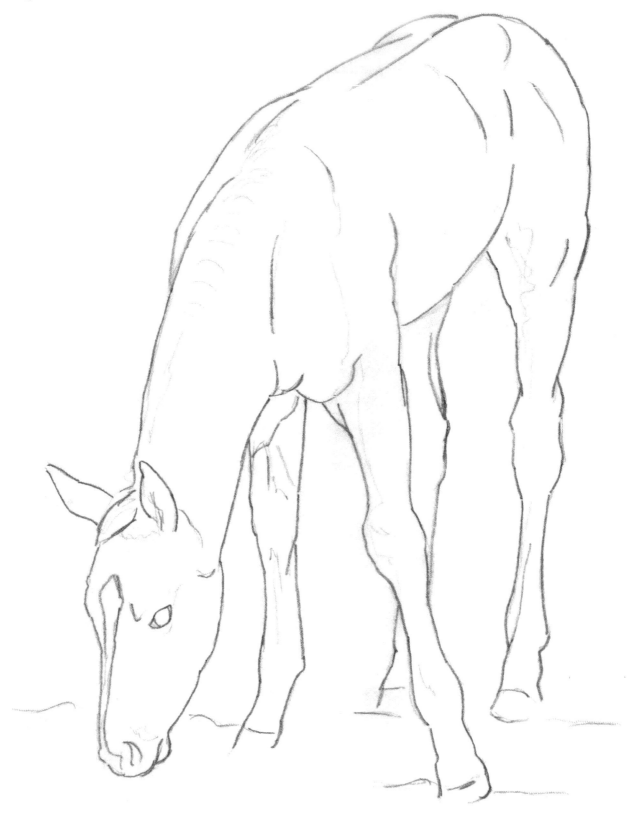

This handsome quarter horse foal belonged to a couple in Lexington, who ran a print shop and raised paints and quarter horses. They invited me to their farm where I got some great references for future drawings and paintings.

MATERIALS

Surface
bristol paper

Pencils
no. 2 pencil
ebony pencil

Other Supplies
kneaded eraser, medium tortillion
(stump), tracing paper (optional)

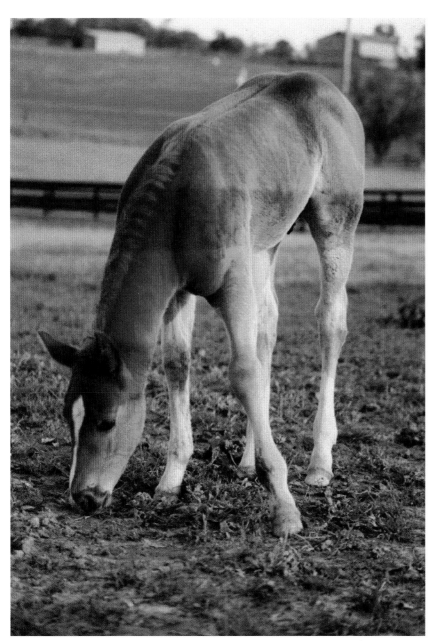

Reference Photo

1 Draw the Main Lines

With a no. 2 pencil, lightly draw or trace the main lines of the foal. Use a sharpened ebony pencil to reinforce these lines and indicate where the main areas of shading will be.

2 Shade In the Darkest Values

With a well-sharpened ebony pencil, shade in the darkest values. Shade lightly at first, gradually darkening the tones with short, smooth strokes that follow the foal's contours. Use some crosshatching in the darker areas such as around the blaze on the face and on the rump.

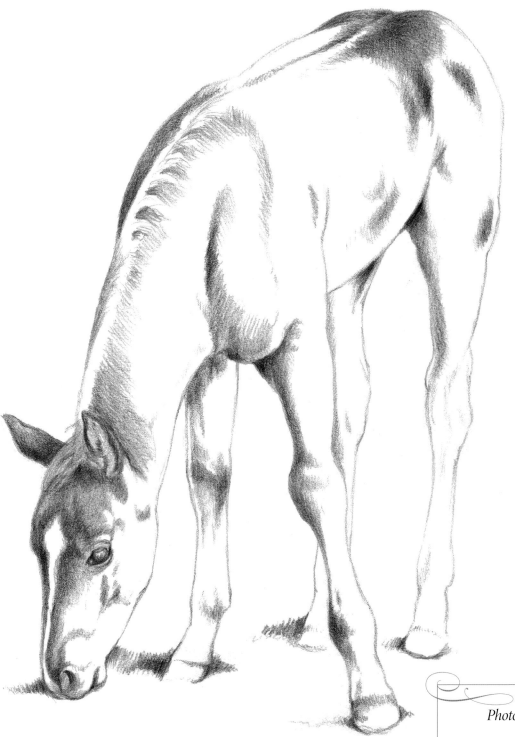

3 Start the Midvalue Tones

Start to shade the midvalue areas of the foal with smooth, parallel strokes. Use a kneaded eraser to make corrections or to lighten areas as needed.

Photographic Flaws

Be aware of the flaws or limitations of reference photos. In this demonstration's reference photo, the shadows of two planks of a wood fence fall across the foal. As an artist, you are free to ignore these shadows.

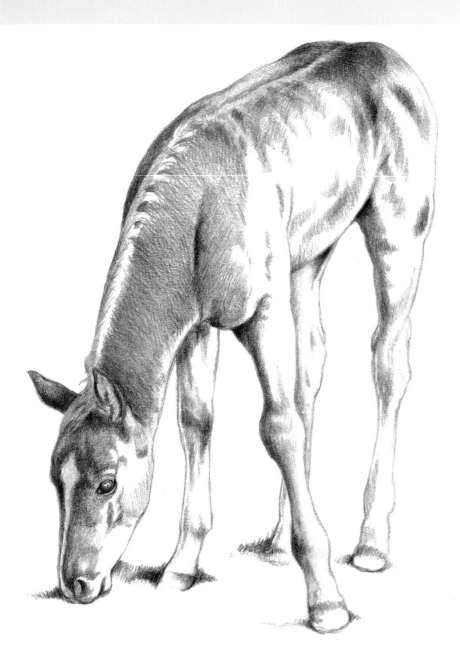

4 Add More Middle Value Tones and Lighter Values

Continue to shade in the middle values. Use longer pencil strokes on the foal's neck, shading with lightly pressured strokes that follow the contours. Gradually darken with additional crosshatched strokes. Start adding the lighter value tones and begin using the stump to blend in the lighter value areas. Lightly shade over the blaze on the face with the stump.

5 Finish the Drawing

Keep refining and adding detail using the ebony pencil and stump. For the broader areas not yet shaded, such as the belly, legs and hindquarters, use the stump to add a light gray tone over the area, using strokes that follow the contours. Leave the highlighted areas white. Shade in detail over the light gray areas with the ebony pencil. Carefully tone down the foal's eyelashes with your pencil and stump.

HANDSOME QUARTER HORSE FOAL
ebony pencil on bristol paper • 8½" × 10" (22cm × 25 cm)

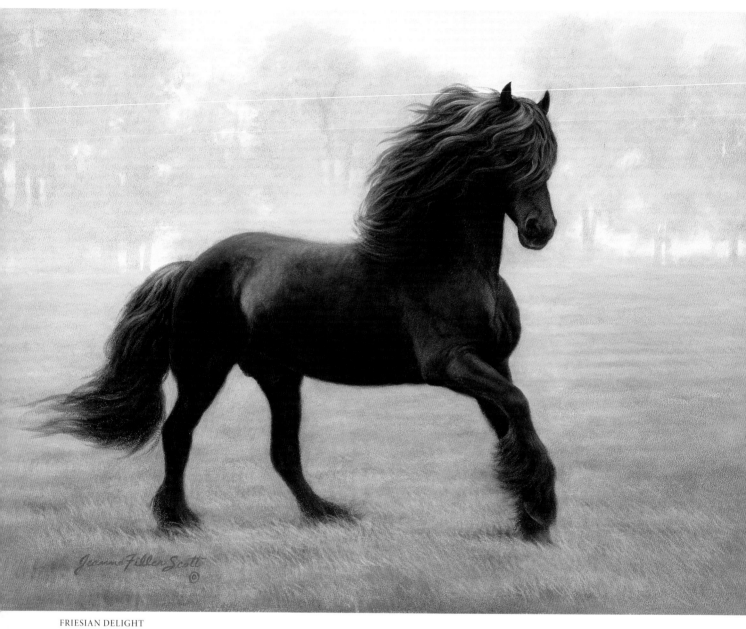

FRIESIAN DELIGHT
acrylic on panel • 18" × 24" (46cm × 61cm) • private collection

Horses in Action

Horses in action strike poses that can be both beautiful and powerful, making them great subjects for both drawing and painting. Other active horse poses can be comical or may show the horse's personality or behavior in more quiet moments. These poses can also be interesting and worthy of the artist's attention.

The three main gaits of the horse are the *walk*, the *trot* and the *gallop*, but horses display many other active poses. There are other gaits such as *pacing* and *cantering*, as well as other activities such as lying down, getting up, rearing up, stamping their feet in alarm or to rid themselves of flies, swishing their tails or scratching their bellies on a convenient tree stump. I have even seen horses carrying around sticks and other objects in their mouths and playing with them. The more you observe horses, the wider variety of actions you will see.

Walking
The walk is the slowest gait. It is called a four-beat gait because the horse puts each foot down separately, one at a time.

Trotting
The trot is a fast, two-beat gait where the diagonal front and hind legs move together, so that the front foot and the hind foot on opposite sides of the horse hit the ground at the same time. While some horses that trot with long strides will at times have all four feet off the ground, others take shorter strides so they never have all four feet off the ground.

Galloping
The gallop is the fastest gait of the horse. It is a four-beat gait where one hind foot hits the ground, then the other hind foot, then the diagonal front foot and then the remaining front foot. At one point the horse has all four feet off the ground.

Rolling
Horses love to roll on the ground to scratch their backs. Watching them, you can tell how good it feels. When they stand up, they proceed to shake the dust off themselves, much like a dog shaking off water.

Scratching
Horses sometimes use their hooves to scratch themselves when they have an itch. I have observed this particular position most often in foals.

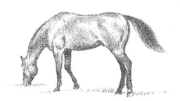

Grazing
When turned out to pasture, horses spend most of their time in this position since it takes them hours to eat the amount of grass they need every day. There is nothing more peaceful looking than a field full of horses grazing to their hearts' content.

Frisky Pony Foal

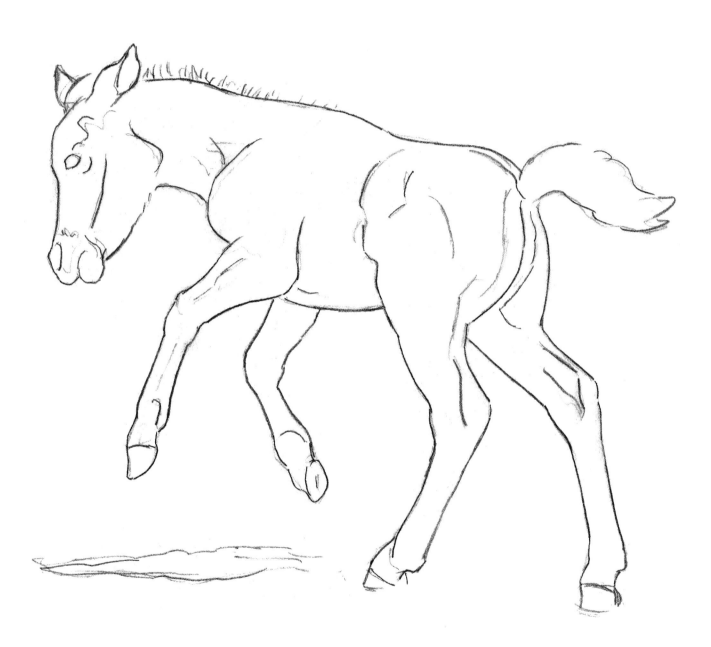

The model for this drawing was our little pony, Epona, when she was only a few weeks old. She weighed only about 25 pounds (11kg) when she was born (in contrast, a Thoroughbred foal weighs about 125 pounds [57kg] at birth), so she was small enough that we could pick her up in our arms. Needless to say, she is very tame and spoiled! At this age, she delighted in running and frisking, trying out her legs. Although she is too heavy to pick up now, my husband still lifts her up by her front legs, making her rear up. He jokingly calls her Black Stallion's Daughter!

MATERIALS

Surface
bristol paper

Pencils
no. 2 pencil

ebony pencil

Other Supplies
kneaded eraser, medium tortillion (stump)

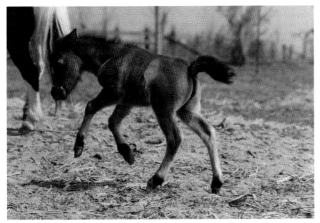
Reference Photo

Sharpen Up!

Sharpen several pencils at the same time so you won't have to keep interrupting your drawing when your pencil gets too dull.

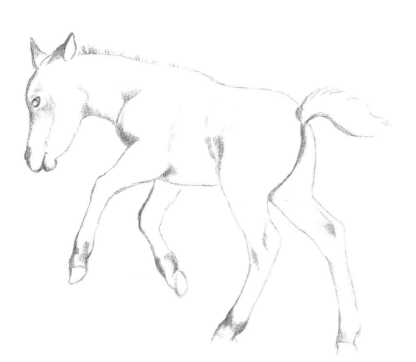

1 Establish the Outline
Lightly trace or draw the outline of the foal onto bristol paper with a no. 2 pencil. With a well-sharpened ebony pencil, go over the basic lines of the foal. Begin to shade the darker areas.

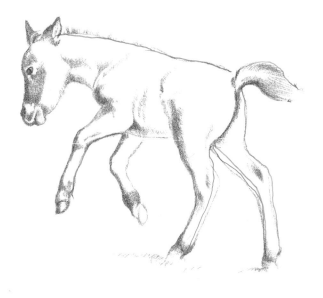

2 Shade In the Darker Values

Continue to shade the darkest areas, lightly at first, gradually darkening with parallel strokes that follow the foal's contours and hair growth pattern. Use longer strokes for the tail.

Soften With a Stump

You can use a stump to add a pleasing soft tone to midvalue areas that have not yet been shaded with your pencil. After creating the tone, add some pencil detail.

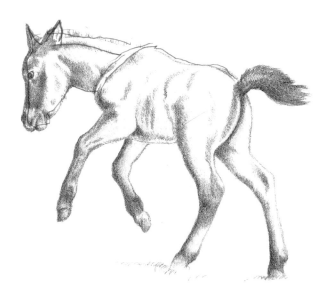

3 Begin to Add Midvalues

Keep shading the dark areas and begin the midvalues, using a stump to blend. With small, parallel pencil strokes, lightly indicate where the larger areas of shadow detail will be.

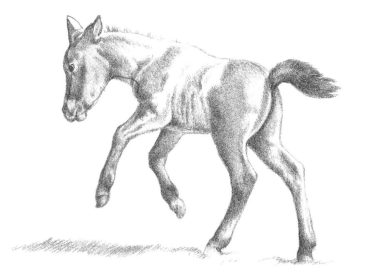

4 Add More Detail

Continue to shade the larger areas of shadow detail with an ebony pencil. Use crosshatching to darken places where you want a softer effect that does not show pencil lines. Crosshatch with the stump to blend and soften further, leaving the highlighted areas white.

Sketch the foal's shadow on the ground with parallel strokes, blending with the stump.

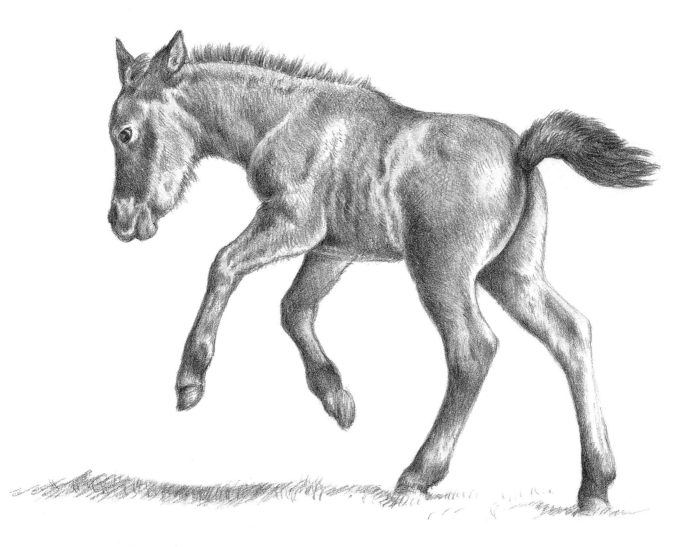

5 Finish the Drawing

Draw the foal's mane with slightly curved strokes, blending with the stump. Finish shading the foal's neck and body with light strokes, using crosshatching and the stump to blend. Add darker detail gradually, blending with the stump. Use your kneaded eraser to make corrections or to lighten areas that have gotten too dark.

Draw some hair from the foal's cheek and jaw with parallel, different-length strokes. Crosshatch the shadow with parallel slanting lines and add a few sprigs of short grass with vertical, slightly curving strokes.

EPONA IN ACTION
ebony pencil on bristol paper • 8½" × 11" (22cm × 28cm)

Rearing Lipizzaner Stallion

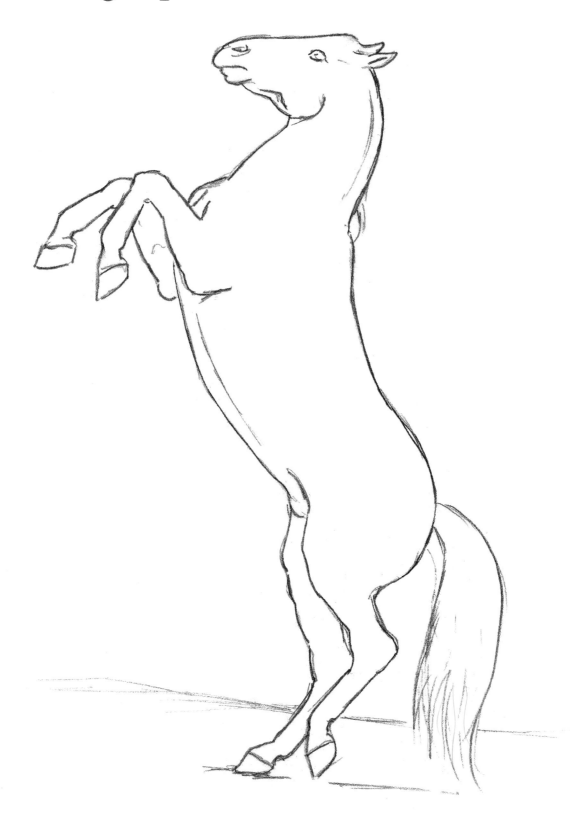

Recently, my husband, son and I attended an event by the World Famous Lipizzaner Stallions held in Lexington. While I was watching, these magnificent white stallions continually inspired me to draw or paint them with their strength, agility and flowing manes and tails. I was able to get some great reference photos, including the photo this drawing is based on. For this demonstration, I chose to draw just the horse without tack or handler, although the photograph would also make a fine drawing or painting reference just the way it is.

MATERIALS

Surface
bristol paper

Pencils
no. 2 pencil
ebony pencil

Other Supplies
kneaded eraser, medium tortillion
(stump), tracing paper (optional)

Reference Photo

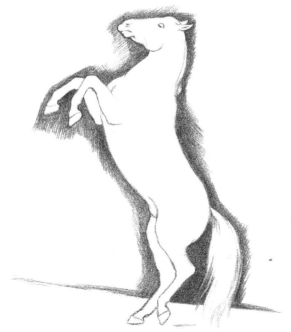

1 Establish the Horse's Outline

Lightly draw or trace the horse's outline onto the bristol paper with a no. 2 pencil. Reinforce the lines with a sharpened ebony pencil.

Begin shading around the horse's contours with the ebony pencil, using hatching and crosshatching. Make any corrections with a kneaded eraser.

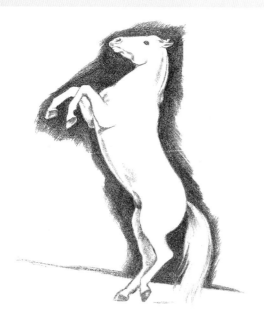

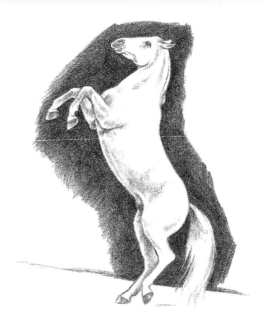

2 Begin to Add Detail

Shade in some of the detail on the horse using a stump to blend. Darken and sharpen the lines around the horse's outline, adding more shading going outward from the horse, gradually darkening with crosshatching.

3 Keep Adding Detail and Background Tone

Continue adding detail to the horse with light parallel strokes that follow the horse's contours. Use a stump to blend in the same direction as the pencil strokes. Keep shading the background tone.

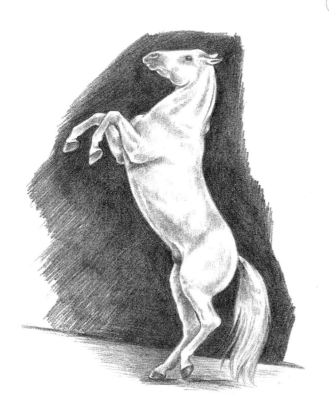

Make Consistent Changes

Since the trainer was standing next to the horse and he is not included in the drawing, eliminate any shadows cast onto the horse by the man or by the tack. When you choose to make changes from your reference, look out for these kinds of inconsistencies.

4 Add More Detail to the Horse and Background

Add shading to the horse's body, blending with the stump. Indicate shadows under the hooves with parallel lines. Begin to shade the medium tone of the carpet the horse is standing on. Make any corrections or lighten areas that have become too dark with a kneaded eraser. To lighten an area, lightly press the eraser down on the spot as many times as it takes to achieve the effect.

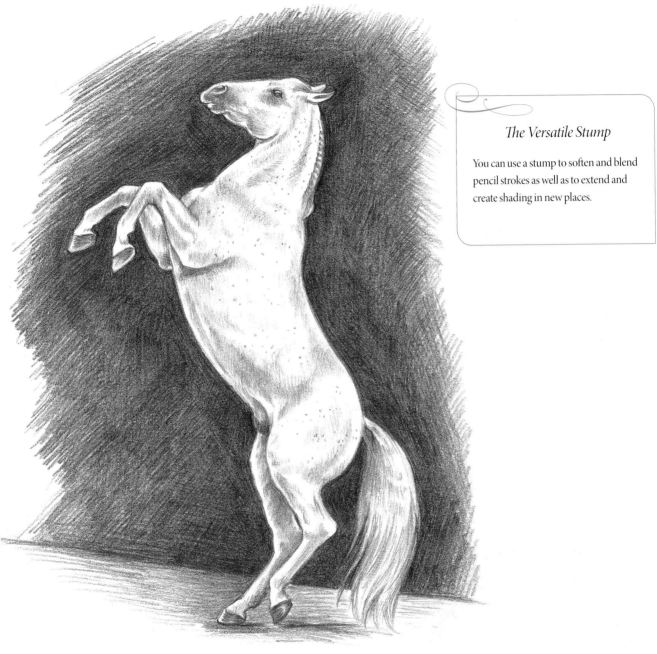

BEAUTIFUL WHITE STALLION
ebony pencil on bristol paper • 7" × 9" (18cm × 23cm)

> ## The Versatile Stump
>
> You can use a stump to soften and blend pencil strokes as well as to extend and create shading in new places.

5 Add the Finishing Details

Draw the rest of the details of the horse, including the braiding pattern on the mane and the small speckles or spots on the coat. If the spots appear too dark, lighten them with the kneaded eraser.

Shade out from the edges of the darkness around the horse, gradually lightening the tone and forming an irregular but pleasing shape around the horse.

Donkey Walking

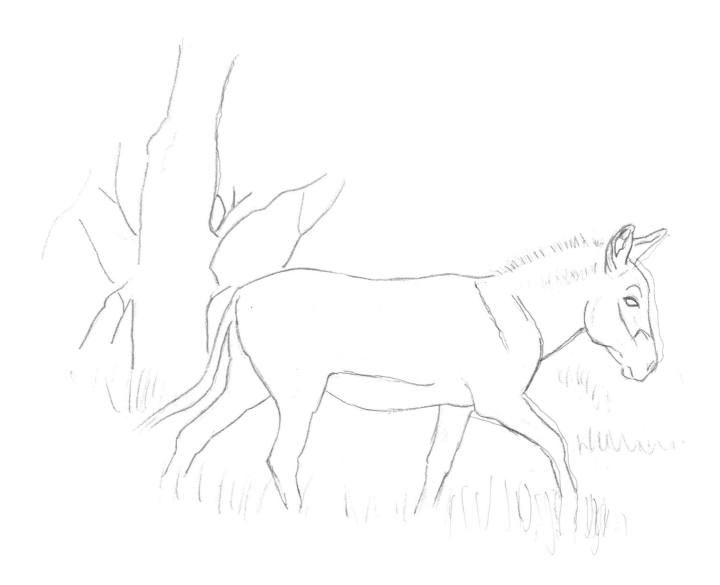

The donkey or burro, a close relative of the horse, is descended from wild donkeys found in northeast Africa. Donkeys have large ears, almond-shaped eyes surrounded by white spectacles, a white muzzle, a tufted tail and black stripes down the back and across the shoulder, a feature also seen in some horses. Donkeys are very tough and can survive with scant food. The donkey's voice, called a *bray*, sounds like a rusty hinge. I saw this donkey walking through a field while I was driving along the back roads of Jessamine County, Kentucky.

MATERIALS

Surface
bristol paper

Pencils
no. 2 pencil
ebony pencil

Other Supplies
medium tortillion (stump), tracing paper (optional)

Reference Photo

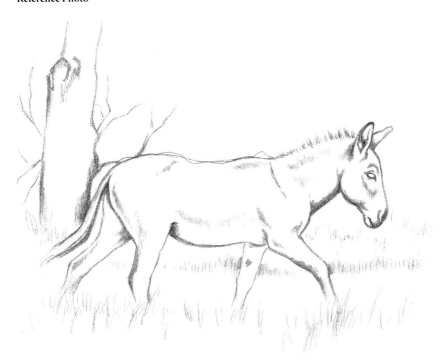

1 Establish the Form
Trace or draw the image onto bristol paper with a no. 2 pencil. Use a sharpened ebony pencil to lightly strengthen the lines. Begin adding some of the dark values.

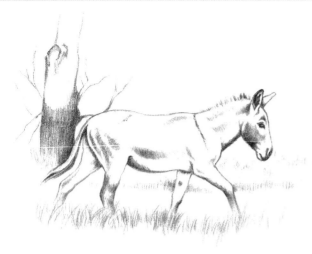

2 Shade In the Darkest Values

Begin to shade in the darkest parts of the donkey with an ebony pencil. Use short, parallel pencil strokes that follow the donkey's contours. Shade lightly, gradually building up the dark tones.

Shade the tree trunk with vertical strokes. Sketch the donkey's shadow in the deep grass with flowing, slightly curving strokes going in different directions, the way grass grows.

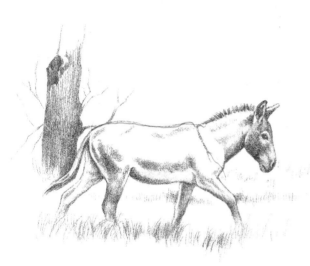

3 Continue Dark Values and Begin Midvalues

Continue to darken the donkey, tree trunk and grass shadow. You can accomplish this by gradually increasing the pressure on your pencil and by crosshatching. Draw the donkey's spiky mane with straight but slightly curved strokes. Use a stump to add a soft tone to areas such as the head, belly and legs, leaving the highlighted areas white.

Stump Pressure

You can control how dark you make the tone by the amount of pressure you use on the stump.

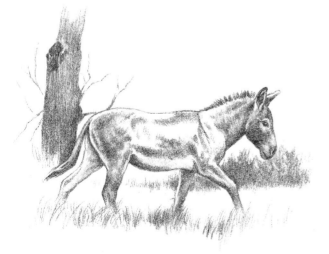

4 Add More Midvalues and Detail

Add shading and detail to the donkey's body, including the dappling pattern on the belly and flank. Blend with a stump.

Shade the rest of the tree trunk, blending with a stump. Sketch in the scrubby weeds behind and in front of the donkey, using a slightly dull pencil. Make soft, light strokes without letting your pencil leave the paper. Blend with the stump and use the stump to create detail at the tops of the weeds.

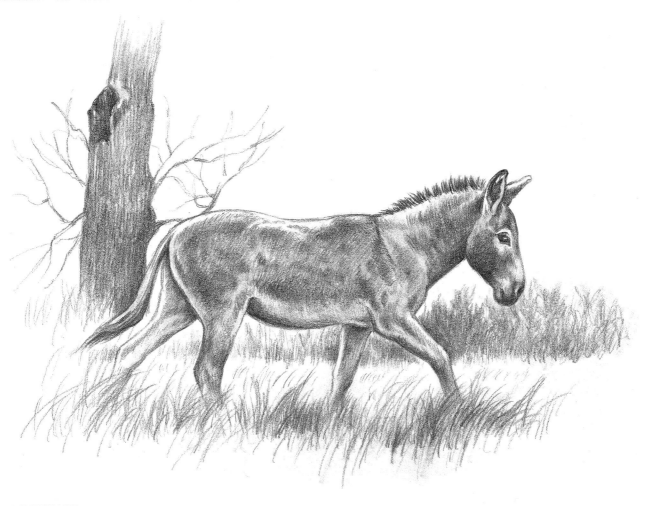

DONKEY WALK
ebony pencil on bristol paper • 8½" × 10½" (22cm × 27cm)

5 Finish the Drawing

Shade in the rest of the tones and details. Sketch more blades of grass around the donkey, making the strokes long and curving, and darkening the shadows a bit more. Expand the line of weeds in front of the donkey a little farther ahead. Add some weed detail under the donkey's belly and hind legs. Add more thin branches to the tree with sketchy strokes.

Toning Hint

Using a stump to add tone to the remaining unfinished and non-highlighted areas will make it easier for you to finish shading in the detail, as white can be very distracting. It will also create a nice, soft underlying tone.

Prancing Arabian Filly

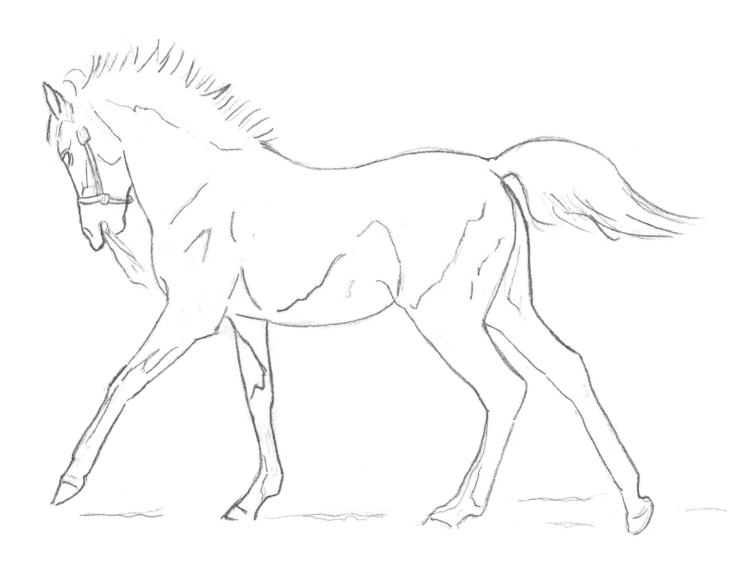

The model for this demonstration was my Arabian horse Poey when she was about ten months old. At this age, she would race around the field, frisking, frolicking and arching her neck. I found this pose particularly appealing as she playfully pranced around with a wisp of hay in her mouth. Poey is a gray horse, but at this stage she looked like a bay.

MATERIALS

Surface
Gessobord panel, 8" × 10" (20cm × 25cm)

Acrylic Pigments
Burnt Sienna, Burnt Umber, Cerulean Blue, Raw Sienna, Titanium White, Ultramarine Blue, Yellow Oxide

Brushes
nos. 1, 4 rounds
nos. 4, 6 filberts

Other Supplies
no. 2 pencil, water

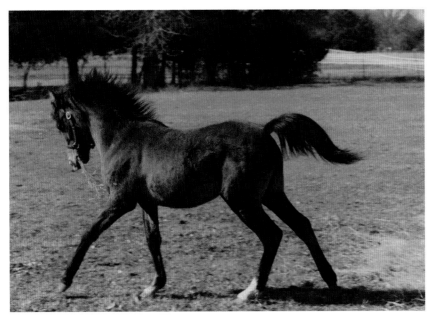

Reference Photo

Color Mixtures

warm black

warm tan

dark smoky gray

blue-gray

hoof color

warm white

reddish brown

medium brown

golden color

bluish shadow color

smoky gray

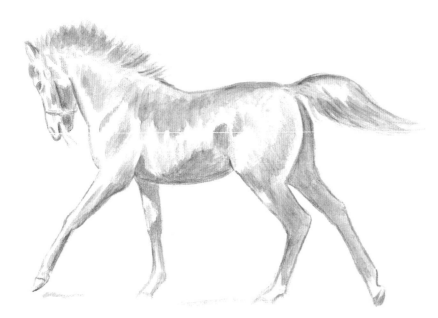

1 Establish the Form

Draw or trace your sketch onto the panel with a no. 2 pencil. With Burnt Umber thinned with water and a no. 4 round, paint the main lines and shadowed areas of the filly. For broader areas, use a no. 6 filbert.

2 Paint the Darkest Value Colors

Create a warm black mix with Burnt Umber and Ultramarine Blue. Paint the darkest areas with a no. 4 round, using a no. 6 filbert for the broader areas. For good coverage, paint a second coat after the first has dried.

Mix a blue-gray for the horse's shadow on the ground with Titanium White, Ultramarine Blue and Burnt Umber. Paint with a no. 6 filbert with sketchy strokes.

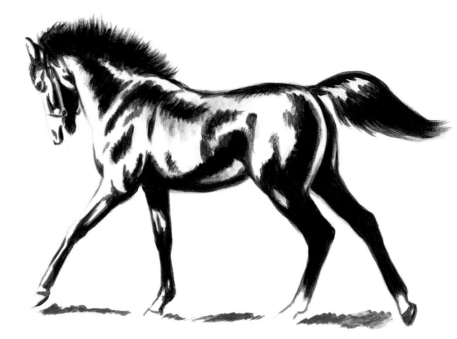

Corrections

To make a small correction, such as painting too far over a line, use a moistened, clean no. 4 round to remove the paint while it is still wet.

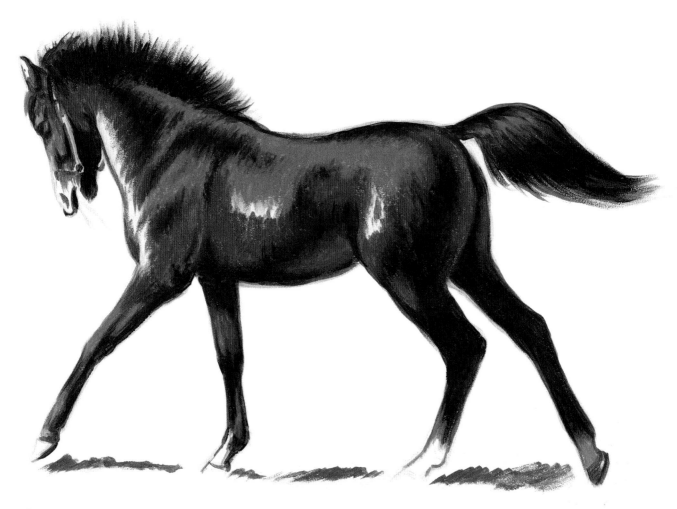

3 Paint the Midvalue Colors

Create the reddish brown mix with Burnt Sienna, Burnt Umber, Yellow Oxide and Titanium White. Paint with a no. 6 filbert, blending with the warm black and a separate no. 6 filbert.

Mix the bluish shadow color with a portion of the blue-gray plus Titanium White. Paint the bluish highlights on the black areas of the coat, mane and tail with a no. 6 filbert, switching to a separate no. 6 filbert to blend with the adjacent color. Use no. 4 rounds for smaller areas such as the head. Use smooth strokes that follow the body contours.

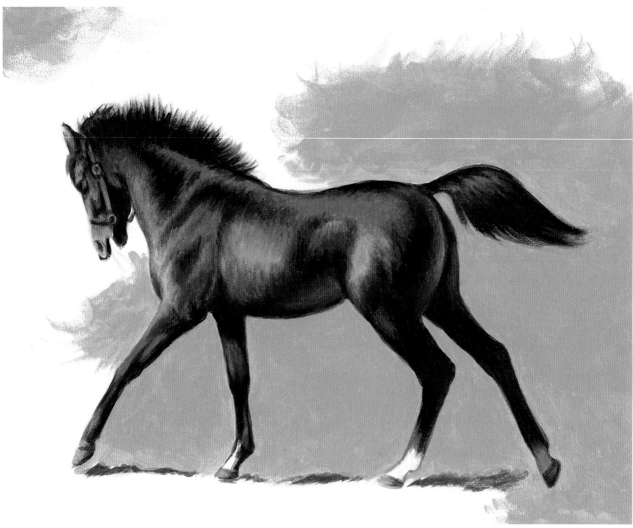

4 Paint Lighter Value Colors and Background

Create the warm tan color with Titanium White, Yellow Oxide, Burnt Sienna and Raw Sienna. Paint with a no. 6 filbert, blending with a separate no. 6 filbert and the adjacent color. Use no. 4 rounds for smaller areas.

Create a hoof color with a little of the warm tan plus a little Ultramarine Blue. Use no. 4 rounds to paint the hooves with warm black for the shadowed parts and hoof color for the lighter areas. Blend where the two colors meet.

Make a medium brown halter color with a little of the warm tan plus Burnt Umber. Paint the halter with a no. 4 round, using a separate no. 4 round and warm black to refine and add shadows.

Mix a smoky gray background color with Titanium White, Cerulean Blue and Burnt Sienna. Begin to paint the background with a no. 4 filbert, using dabbing, semicircular strokes.

Paint around the filly's outline with a no. 6 filbert, using smooth, careful strokes, then blend outward with dabbing strokes. Use a no. 4 round for tighter areas, such as between the legs.

Just Enough

If you need only a small amount of paint on your brush, such as for the halter, dip your brush in the paint, then touch it lightly to a paper towel. You will learn how to get just the right amount of paint to do the job.

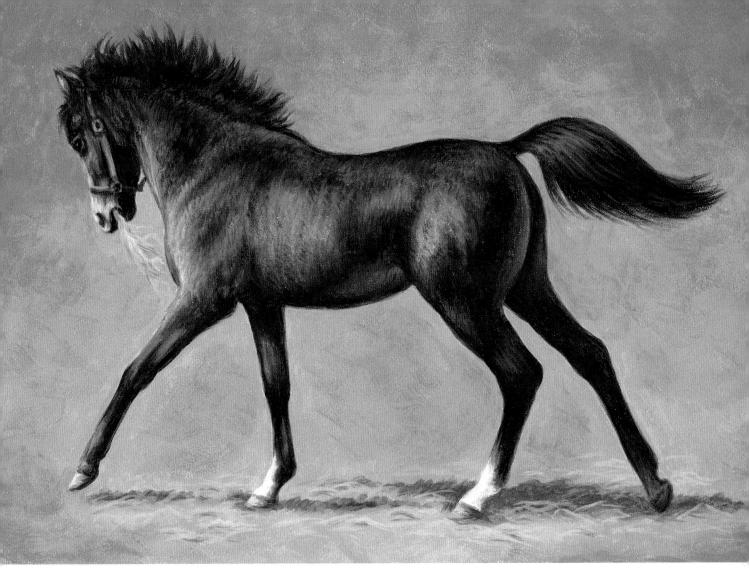

POEY THE PRANCER
acrylic on Gessobord • 8" × 10" (20cm × 25cm)

5 Finish the Background and Add Detail to the Filly

Mix a dark smoky gray background color (use the Step 4 colors with less Titanium White). Paint the top part of the painting with a no. 4 filbert, using a separate no. 4 filbert to blend with the smoky gray. Use drybrushing to blend the edges of the colors. Use the same technique to add some darker smoky gray to the other parts of the background with a light pressure on your brush, blending with the smoky gray using dabbing strokes.

Reestablish the filly's outline with a no. 4 round and the appropriate color. Reestablish the filly's shadow on the ground with the blue-gray and a no. 6 filbert. Blend the edges with smoky gray and a separate no. 6 filbert.

Mix warm white with Titanium White and a small amount of Yellow Oxide. Use no. 4 rounds to paint the filly's socks on the right front and left rear legs, blending with bluish shadow color and warm black.

Use warm black to add detail to the bluish shadow and reddish brown areas of the coat with a no. 4 round, with small parallel strokes. Blend with the adjacent color. Use no. 4 rounds to add detail to the warm tan areas with reddish brown. Add detail to warm black areas with the bluish shadow color.

Paint flowing lines from the mane and tail with warm black and a no. 4 round. With a no. 1 round and the bluish shadow color, paint a highlight in the eye. Add highlights to the muzzle, ear and chest with warm white and a no. 4 round. Switch to a no. 1 round to add highlights to the hooves, except for the hoof in shadow. Blend all highlights with the adjacent colors.

Create a golden color for the wisp of hay in the filly's mouth with Titanium White and Yellow Oxide. Paint with a no. 1 round. Use medium brown to paint a few strands in shadow. Paint a few strokes of hay on the ground around the filly's shadow, using the blue-gray to paint shadows in the hay.

Friesian Stallion Trotting

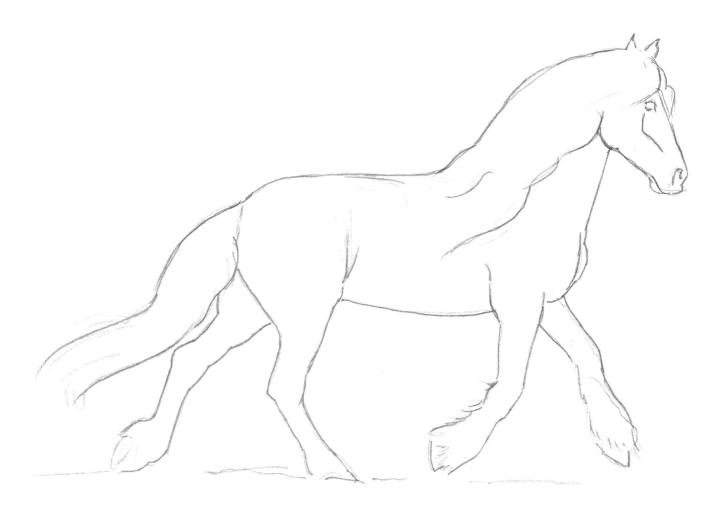

The subject of this drawing was a Friesian stallion named Frieske, who was at the Kentucky Horse Park. The people who work at the park were very kind, giving me a private showing of this amazing horse. It was a real thrill to watch Frieske walk, trot and gallop around the field, his luxurious mane and tail flying in the wind. Several paintings and drawings have resulted from that visit .

MATERIALS

Surface
bristol paper

Pencils
no. 2 pencil
ebony pencil

Other Supplies
kneaded eraser, medium tortillion
(stump), tracing paper (optional)

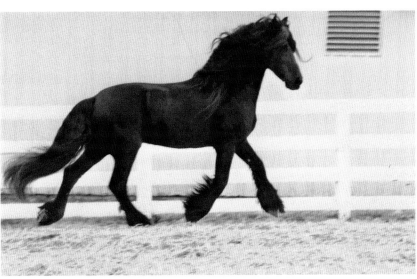

Reference Photo

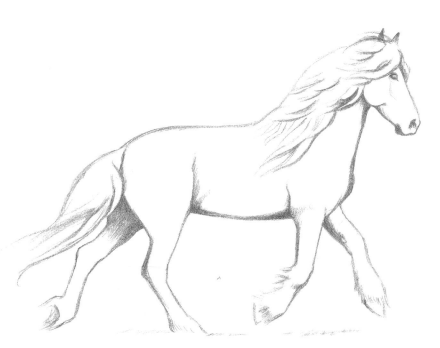

1 Establish the Form
Draw or trace the image onto bristol paper with a no. 2 pencil. With a sharpened ebony pencil, lightly go over the lines and begin to shade in the darkest areas. Use parallel strokes that follow the horse's contours.

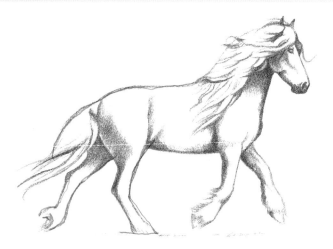

2 Shade In More Dark Areas

Continue to shade in the darkest areas with parallel strokes. Darken gradually, using crosshatching.

Begin to block out the boundaries of the darker areas with light, parallel strokes.

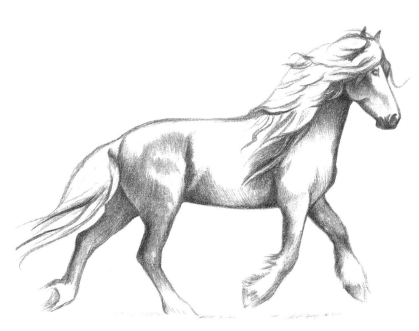

3 Shade Dark and Midvalues

Keep shading the dark areas and begin to transition to some of the midvalue areas. Use a stump to blend, stroking in the same direction as the pencil lines.

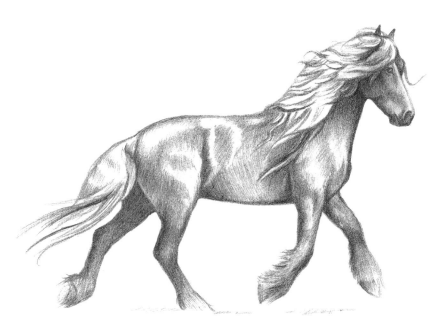

4 Continue Shading the Horse's Coat and Add Detail to the Mane and Tail

Finish defining the boundaries of the major areas of light and dark values in the coat. Sketch the shapes of the locks of hair in the mane and tail with flowing lines. Continue to darken the shadowed parts of the horse's coat.

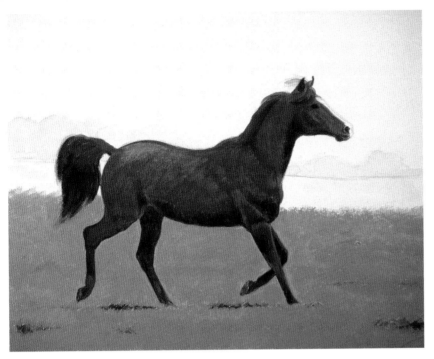

3 Paint the Midvalue Colors and Begin the Background

Mix the red chestnut color for the horse's coat with Burnt Sienna and Cadmium Orange. Paint with a no. 6 round, using strokes that follow the horse's contours. For good coverage, add a second coat when the first is dry. Begin to reestablish the dark value areas with a no. 4 round and the dark brown from Step 2.

Mix the basic grass color with Hooker's Green, Cadmium Orange, Yellow Oxide, Titanium White and a small amount of Hansa Yellow Light. Paint with a no. 4 filbert, using dabbing strokes, about three-quarters of the way up to the horizon. Use a no. 4 round to paint around the horse.

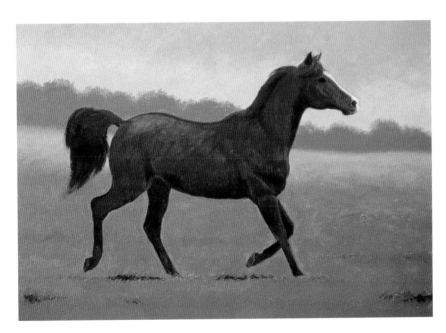

4 Paint the Sky and the Remainder of the Field

Make a light green for the upper fourth of the field with the basic grass color mixed with Titanium White, Yellow Oxide and Hansa Yellow Light. Paint with a no. 4 filbert, using a second brush to blend.

Mix blue-green for the trees with Titanium White, Hooker's Green, Ultramarine Blue, Cadmium Orange, Yellow Oxide and a little Hansa Yellow Light. Paint dabbing strokes with a no. 10 fil-

bert, switching to a no. 6 round to paint around the horse. Blend where the horizon line meets the tree line with a no. 4 round.

Mix the blue sky color with Titanium White, Ultramarine Blue and a little Yellow Oxide. Make a light blue for the lower quarter of the sky by adding more Titanium White and a little Yellow Oxide. Paint with separate no. 4 filberts for each color, blending where they meet, using semicircular dabbing strokes. With a no. 4 round and the blue-green color, paint feathery strokes from the tops of the trees overlapping the sky.

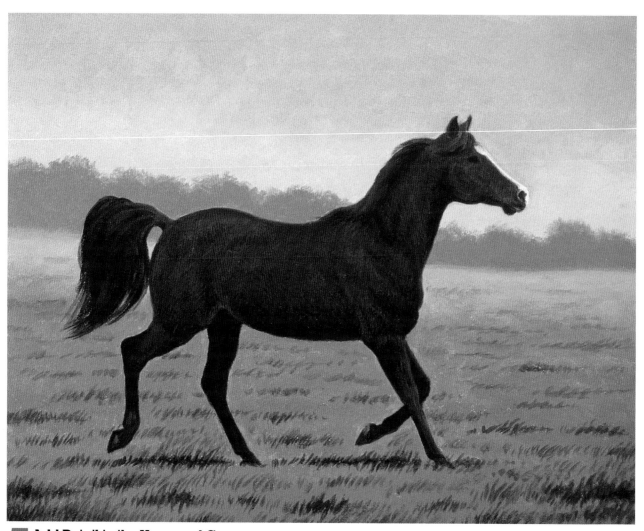

5 Add Detail to the Horse and Grass

Strengthen the horse's dark areas and the midvalue red chestnut color with no. 6 rounds. Paint more detail in the coat and blend the edges of the dark areas with the dark brown color and a no. 6 round, using light-pressured, parallel strokes that follow the horse's contours.

Paint dark detail areas in the grass with a no. 6 round and the dark green color from Step 3, using roughly vertical strokes in varying directions. Use a light pressure on the brush, and make the shadows smaller and lighter as you go back into the landscape.

Control Detail Darkness

By varying the amount of paint on your brush, you can control the darkness of the detail and make it more realistic. Use less paint for the clumps of grass in the background and for grass detail in between the main grass shadows in the foreground.

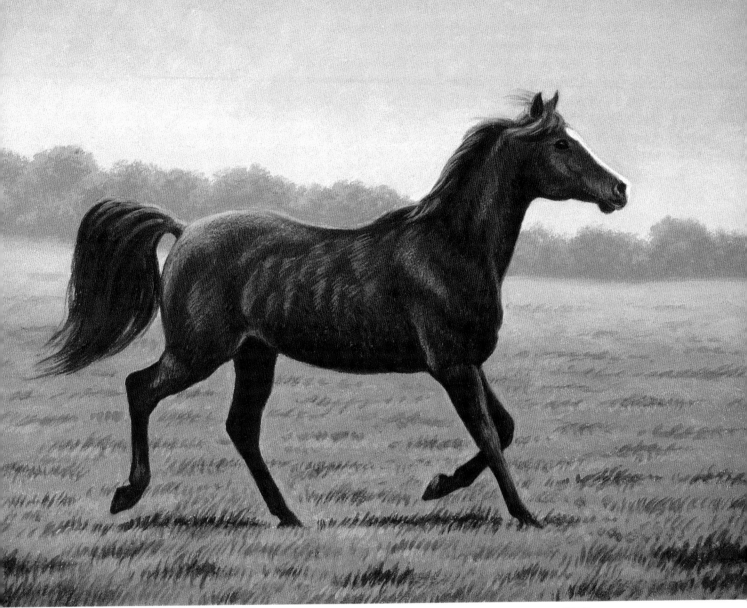

SHAMMAR IN ACTION
acrylic on Gessobord • 8" × 10" (20cm × 25cm)

6 Paint Light Value Colors and Finishing Details

Mix a highlight color for the horse with Titanium White, Hansa Yellow Light and Cadmium Orange. Paint the highlights with a no. 4 round, blending down into the red chestnut color with the dry-brush technique. Paint the highlights on the belly and flank with light parallel strokes. Tone down and blend the highlights with a separate no. 4 round and the red chestnut color.

Mix warm white with Titanium White and a touch of Hansa Yellow Light for the horse's white blaze. Paint with a no. 4 round.

Paint a highlight in the eye with a little of the light blue sky color from Step 4 and a no. 1 round.

Mix a highlight color for the grass with a portion of the light green grass color from Step 4 mixed with some Cadmium Orange and Hansa Yellow Light. Paint with a no. 4 round, using dabbing, vertical strokes. Mix a warm brown with a bit of this color and a bit of the red chestnut color and paint dabbing strokes in the grass with a no. 4 round. This will integrate the horse with the background and add realism to the field.

Mix a highlight color for the trees with some of the blue-green tree color from Step 4 and a portion of the light green grass color. Paint with a no. 4 round using dabbing strokes, blending with a separate no. 4 round and the blue-green color.

Gallery

Here are a few of my equine paintings. Since I am surrounded by the Bluegrass of Kentucky, many of my subjects are thoroughbreds.

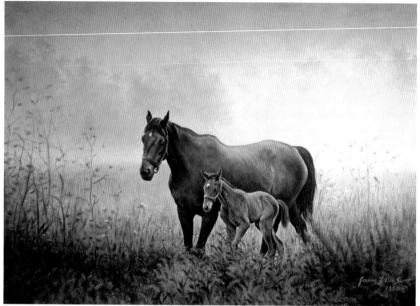

THE OVERGROWN PASTURE
oil on canvas • 15" × 21" (38cm × 53cm) • private collection

Unusual Setting

I painted *The Overgrown Pasture* after a morning visit to Elmhurst Farm near Lexington, Kentucky. I was attracted to the sight of a thoroughbred mare and foal walking through tall weeds, unlike the well-kept horse farms I usually see. *The Young Aristocrat* (see page 8) was another painting that resulted from that visit.

FALL GRAZING
acrylic on panel • 8" × 10" (20cm × 25cm) • artist's collection

Grazing Mares

Fall Grazing, three thoroughbred mares grazing in an early autumn landscape, resulted from a trip to Waterford Farms in Midway, Kentucky.

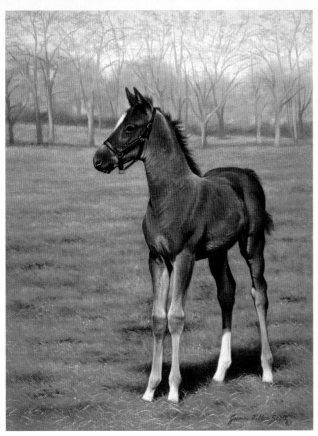

Proud Foal

The Little Prince is a thoroughbred foal I saw at Windmill Farm in Woodford County, Kentucky, which is owned and operated by my aunt and her family. The foal was such a proud little fellow that I just had to paint him. I also saw the mare and foal running together, the subject of *Cresting the Hill*, at Windmill Farm (see pages 7 and 126).

THE LITTLE PRINCE
oil on panel • 18" × 24" (46cm × 61cm) • artist's collection

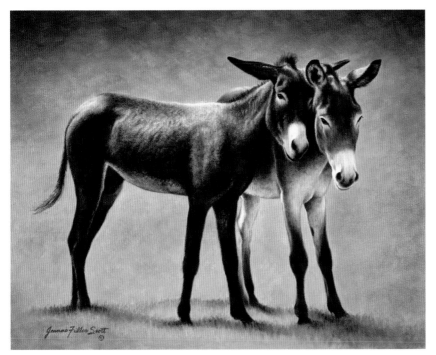

Affectionate Burros

The burros in *Me and My Gal* were at the Kentucky Horse Park, and were available for adoption from the U.S. Bureau of Land Management Wild Horse and Burro Adoption program. They were so endearing and affectionate with each other I felt they would make a great subject matter to paint.

ME AND MY GAL
oil on panel • 16" × 20" (41cm × 51cm) • private collection

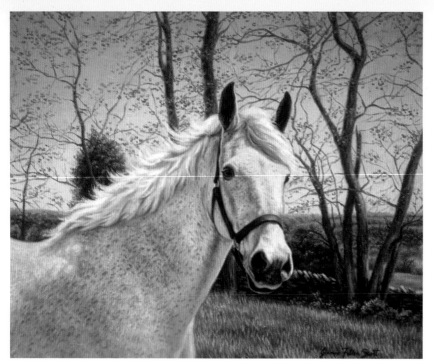

CAMELOT AT HOME
oil on canvas • 12" × 14" (30cm × 36cm) • private collection

Capturing Personality

Camelot at Home was commissioned by a lady whose family owned a famous racehorse farm in Lexington, Kentucky. At the time she was in her 80s and she still rode her hunter jumper horse, Camelot. As she was very attached to this sweet-natured horse, she commissioned me to paint a head and shoulders portrait of him. She wanted the focus of the painting to be on the horse's personality. When I presented the finished portrait to her, she was so pleased with it that she cried. This was a very moving and gratifying experience for me as an artist. To be able to give joy to another through one's art certainly contributes to making the process of painting so rewarding.

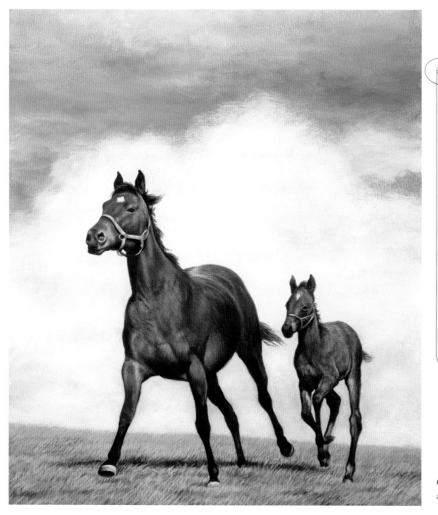

Happy Trails

Horses are a wonderful subject for the artist. There is such a variety in the world of horses—so many different breeds, colors and types of horses, as well as activites which involve people with horses—that an artist would never even begin to run out of material!

I hope that you have learned a lot and have had fun going through this book, and that it will provide a valuable reference for you as you continue to pursue the art of drawing and painting horses.

CRESTING THE HILL
acrylic on panel • 16" × 12" (41cm × 30cm) • artist's collection

Index

Ideas. Instruction. Inspiration.

Master artist William Silvers shares his secrets for capturing the drama, the atmosphere and the very essence of wildlife so you can also create emotion-filled wildlife paintings. These incredible wildlife scenes will make your pulse quicken and your breath catch as you witness some of nature's most miraculous everyday moments.

ISBN-13: 978-1-60061-135-3
ISBN-10: 1-60061-135-4
Paperback, 144 pages, #Z2298

What could speak more to the creative soul an artist than a full year of the world's leading art magazine for fine artists? Packed with tips, techniques, full color instruction and advice from the pros, you will be inspired all year long by every issue of *The Artist's Magazine*.

Find the latest issues of *The Artist's Magazine* on newsstands, or visit www.artistsnetwork.com.

Claudia shows you how to see animals with an artist's eye so you can draw them with ease. Through a series of mini step-by-step demonstrations and one complete step-by-step demonstration, Claudia uses visual comparisons to accurately draw animals that are both realistic and expressive.

ISBN-13: 978-1-4403-0877-2
#Z9841, DVD running time: 89 minutes

Receive a FREE downloadable issue of *The Artist's Magazine* when you sign up for our free newsletter at **www.artistsnetwork.com/newsletter_thanks.**

These books and other fine North Light products are available at your favorite art & craft retailer, bookstore or online supplier. Visit our websites at **www.artistsnetwork.com** and **www.artistsnetwork.tv**.

Visit www.artistsnetwork.com and get Jen's North Light Picks!

Get free step-by-step demonstrations along with reviews of the latest books, videos and downloads from Jennifer Lepore, Online Education Manager at North Light Books.

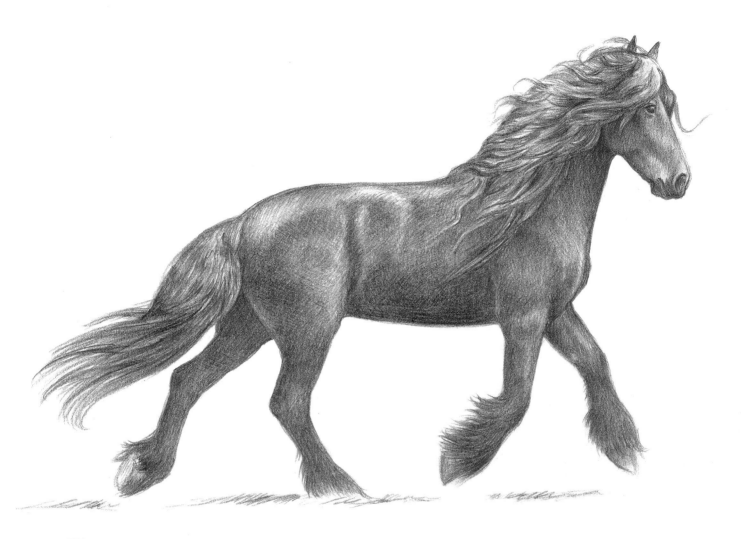

5 Finish the Drawing

Finish darkening the belly, neck, legs and hindquarters, using crosshatching and blending with a stump. Darken and add detail to the mane and tail. Use a kneaded eraser to lighten dark areas or to make corrections. Draw more lines in the tail with sweeping, curved strokes. Draw the horse's shadow with short, sketchy, slanted strokes. Blend with a stump.

AMAZING TROTTER
ebony pencil on bristol paper • 8" × 12" (20cm × 30cm)

Trotting Arabian Gelding

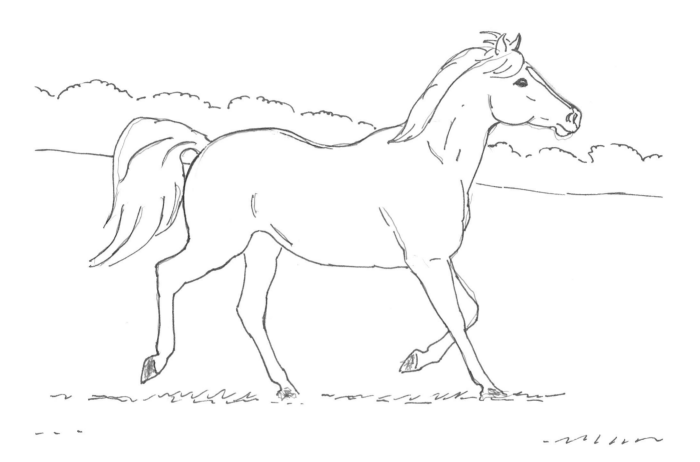

The model for this painting was my Arabian horse Shammar. I acquired Shammar when he was at least fifteen years old (a horse's age can be determined from looking at its teeth up to the age of fifteen, but after that, the horse's age cannot be told with any accuracy). I had Shammar for the next nineteen years, so he was at least thirty-four years old when he passed away, and possibly older. Shammar was down on his luck before he came to live with us. His owners had left him at a stockyard, where he had been sold at auction to a horse dealer, who in turn sold him to the dealer I got him from. Shammar was very nervous and jumpy when he first came to our farm, but he gradually settled down. I miss him. He was a good horse, and I'm glad I was able to provide a secure and permanent home for him, where he could live out his life in peace and comfort.

MATERIALS

Surface
Gessobord panel, 8" × 10" (20cm × 25cm)

Acrylic Pigments
Burnt Sienna, Burnt Umber, Cadmium Orange, Hansa Yellow Light, Hooker's Green, Titanium White, Ultramarine Blue, Yellow Oxide

Brushes
nos. 1, 4, 6 rounds
nos. 4, 10 filberts

Other Supplies
no. 2 pencil, water

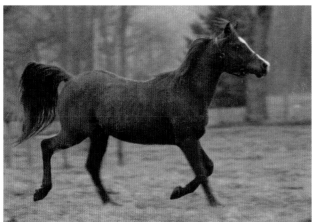

Reference Photo

Color Mixtures

dark brown

dark green

red chestnut

basic grass color

light green

blue-green

blue sky color

light blue

horse highlight color

warm white

light green grass color

warm brown

tree highlight color

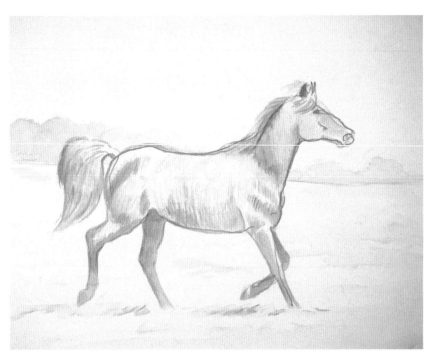

1 Establish the Form

Lightly trace or sketch the horse and background onto the panel with a no. 2 pencil. Use Burnt Umber thinned with water and a no. 4 round to paint the main lines and contours of the horse and background.

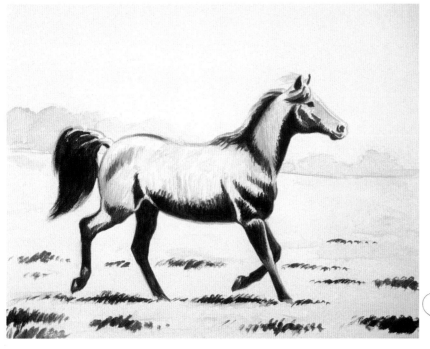

2 Paint the Dark Value Colors

Mix the dark brown for the shadowed parts of the horse's coat with Burnt Umber, Burnt Sienna and Ultramarine Blue. Paint the broader areas with a no. 6 round, switching to a no. 4 round for more detailed areas.

Mix the dark green for the grass shadows with Hooker's Green, Burnt Umber, Cadmium Orange and Ultramarine Blue. Paint with a no. 6 round, using dabbing parallel strokes.

Lighting Conditions

The reference photo was taken on a drab, overcast day, so the horse's color appears darker than normal. It is helpful to refer to other photos taken under better lighting conditions that show the rich red color of the coat.